SIGNALLING AND SIGNAL BOXES

Along the LB&SCR and Isle of Wight Railway Routes

Allen Jackson

AMBERLEY

For Ninette.

First published 2017

Amberley Publishing
The Hill, Stroud,
Gloucestershire, GL5 4EP

www.amberley-books.com

Copyright © Allen Jackson, 2017

The right of Allen Jackson to be identified as the Author
of this work has been asserted in accordance with the
Copyrights, Designs and Patents Act 1988.

All rights reserved. No part of this book may be reprinted
or reproduced or utilised in any form or by any electronic,
mechanical or other means, now known or hereafter invented,
including photocopying and recording, or in any information
storage or retrieval system, without the permission in writing
from the Publishers.

ISBN: 978 1 4456 6930 4 (print)
ISBN: 97 8 14456 6931 1 (ebook)

British Library Cataloguing in Publication Data.
A catalogue record for this book is available from the British Library.

Typeset in 10pt on 13pt Celeste.
Typesetting by Amberley Publishing.
Printed in the UK.

Contents

Introduction 5

Signal Boxes & Infrastructure on Network Rail 6

Summary of Contents 11

London, Brighton and South Coast Railway (LBSCR) 13

Isle of Wight Railway 85

References & Acknowledgements 95

Introduction

The Southern Railway was the smallest of the 'Big Four' and relied on passenger traffic for its wealth; this was in direct contrast to the other three, who saw freight as the main earner.

The Southern Railway embarked on a programme of third rail electrification in the late 1920s, and some of the semaphore signalling was removed then. Subsequent modernisation under British Railways in the 1960s saw off even more of the mecanical methods.

The Southern had its own way of approaching signalling matters and that adds to its interest and fascination. However, as the semaphore signalling and signal box scene is relatively sparse when compared with that of other railway companies, it has been decided to add to this book's content by including items of railway infrastructure to the recipe.

The Southern Railway consisted of the following pre-Grouping companies, for which an identifiable signalling presence exists:

London, Brighton and South Coast Railway (LBSCR)
Isle of Wight Railway (IOWR)
South East and Chatham Railway (SECR)
London and South Western Railway (LSWR)

The first two railways form the first volume of this trilogy, which is to be followed by instalments covering the SECR and LSWR.

In the book the system of units used is the imperial system, which is what the railways themselves still use, although there has been a move to introduce metric units in certain instances, such as Railway Accident Investigation Branch reports and on the HS1 from St Pancras to the Channel Tunnel at Folkestone. Distances and quantities will have a conversion to metric units in brackets after the imperial units used.

1 mile = 1.6 km, 1 yard = 0.92 m, 1 chain = 22.01 m. 1 chain = 22 yards. 1 mile = 1,760 yards or 80 chains.

Signal Boxes & Infrastructure on Network Rail

Introduction

The survey was carried out between 2005 and 2016, and represents a wide cross section of the remaining signal boxes on Network Rail on former Southern Railway metals. Inevitably some have closed and been demolished; others have been preserved and moved away since the survey started. Where some closed signal boxes remain in their original position on Network Rail, they have been included; many are of interest not only for their former function but also for their architectural merit.

Although the book is organised around the pre-Grouping companies, the passage of time has meant that some pre-Grouping structures have been replaced by SR or BR buildings. Some of the signal boxes have been reduced in status over the years and, while they may have controlled block sections or main lines in the past, some no longer do so.

Details of the numbers of levers are included but not all the levers may be fully functional as signal boxes have been constantly modified over the years.

Lever colours are:

RED	-	Home Signals
YELLOW	-	Distant Signals
BLACK	-	Points
BLUE	-	Facing Point Locks
BLUE/BROWN	-	Wicket gates at level crossings or locks
BLACK/YELLOW CHEVRONS	-	Detonator placers (no longer used but some signal boxes retain the levers)
WHITE	-	Not in use
GREEN	-	King Lever to cancel locking when single line box switched out
WHITE-/BROWN	-	Acceptance lever

Levers under the block shelf or towards the front window are usually said to be 'normal' and those pulled over to the rear of the box are said to be 'reversed'. Similarly, points that

are in a position that reflects normal on the lever are described as being in the normal position and the converse with reversed is true. Signals at danger are described as 'ON' and in the go position are described as 'OFF'. Distant signals that are ON are described as at 'CAUTION'.

There are some boxes where the levers are mounted the opposite way round – in other words, levers in the normal position point to the rear wall – but the convention remains the same.

Ground frames are mechanical lever frames that do not have a building over them in the guise of a signal box. They are usually at ground level and can be operated by the train driver or staffed by a signaller. They are often 'released' or enabled by a supervising signal box that may be some distance away, and not in visual contact with the person operating the frame.

Many signal boxes have been modified over the years, with their lever frames removed and replaced with a panel equipped with switches and indicator lights or even a computerised Visual Display Unit (VDU), where the track layout is represented by a digital graphic. This offers a live representation of the position of points and signals, while trains are depicted on the graphic by their reporting number codes. Signallers make route changes by the use of a tracker ball, which is essentially a static mouse.

Signal boxes have assumed far more duties over the years and now will typically supervise several remote level crossings, often by CCTV or simply by telephone with the user, which is in many cases a farm worker.

Listed Buildings

Many signal boxes and other railway-related structures are considered to have architectural or historic merit, and are Grade II listed by Historic England. This means they cannot be changed externally without permission. However, if Network Rail allows the building to decay to such an extent that it is unsafe, the building can then be demolished.

Signal Box Official Abbreviation

Most signal boxes on the former Southern Railway of Network Rail have an official abbreviation of up to three letters and each signal then has the code followed by a discrete number that identifies a particular signal. This code usually appears on all signal posts relevant to that box. The abbreviation for each box appears after the box title in this book, if it has one.

Signal Box Official Title

The signal box title contained in the original Act of Parliament for the line has been used. As state education for most was not available until the 1850s, some of the titles were drafted by clerks who were either ill-educated or who had received no education at all. Consequently, grammar and punctuation are sometimes present and sometimes not.

Ways of Working

Absolute Block – AB

A concept used since railways began, almost, is a block of track where a train is permitted to move from block to block, provided no other train is in the block being moved also. There are variations, with such things as 'permissive working', but these are confined to freight-only lines.

This relies on there being Up and Down tracks. Single lines have their own arrangements. It is usual to consider trains travelling in the Up direction as going towards London, but there are local variations and this is made clear in the text.

This block system was worked by block instruments that conveyed the track occupancy status and by a bell system that was used to communicate with adjacent signal boxes.

The signallers rely on single-stroke bells for box-to-box communication; although this is supplemented by more modern means, the passage of trains is still today controlled in this way. A typical communication for the passage of an express passenger train (Network Rail Class 1) from signal box A to signal box B would be as follows (*the text in **bold** is the instigator and that in plain text the reply*):

Signal Box A		Signal Box B	
Activity	Bell Code	Activity	Bell Code
Call Attention	1	Acknowledge	1
Line clear for Express?	4	Acknowledge Line is clear for Express	4
Train entering block section	2	Acknowledge Train entering block section	2
Acknowledge Train leaving block section	2.1	**Train leaving block section** **(Train Out of Section - TOS)**	2.1

Each time an activity is done, the situation as to the position of the train is reflected through block instruments by the signaller at signal box B, which is the receiving box. All selections are reflected on signal box A's instrument. The status of a block can be one of the following:

Normal – Line Blocked
Line Clear
Train on Line

This procedure is repeated along the line to subsequent signal boxes. The absolute block system refers to double lines and the above procedure is for one line of track only. With

double track, it is not unusual to have two sets of dialogue between adjacent boxes as trains pass each other on separate lines in different directions.

In our example, although only the Up line has been shown, a train could be travelling from A to B on the Up line with another train on the Down line travelling from B to A.

The Southern Railway used some bell codes that no other railway used and also had a set of codes that described the route that a particular train was to take. Train describers were a late nineteenth- or early twentieth-century means of achieving the same thing. Basically, an analogue-type telephone dial would transmit an electrical signal that manifested itself as an indicator in the next signal box of the destination of the next train. This system worked well enough for about sixty years, but lacked a recording function. The operation of the dial for a succeeding train overwrote the indication for the previous one. In a busy location, this was a real disadvantage.

Track Circuit Block – TCB

Originally track circuits lit a lamp in a signal box to indicate where a train was. They worked by passing a small current through track that was electrically insulated at the end of the track circuit. The presence of a train would short-circuit the track and cause a lamp to light in a signal box. Originally they used DC circuits with batteries, but long sections of welded track have meant that AC of differing frequencies is used. The system knows where the train is by which frequency circuit has been affected. This is a bit like saying that if it's 88.9 MHz on the FM radio frequency dial, it must be Radio 2.

In addition, as the Southern has large portions of DC electrified track, where the running rails are the power return, DC track circuits would not work as the track circuit current would be swaped by the train power current. A simplified diagram of track circuits appears at p. 10.

Track circuits were used to interlock block instruments, signals and points together to provide a safe working semaphore signal AB environment; this system is known as the Welwyn Control in memory of the 1935 accident at Welwyn Garden City on the LNER.

With colour light signals, it is possible to provide automatically changing signals that are controlled by the passage of trains or presence of vehicles on the track. The Train Out of Section of AB working can be technologically acquired by the use of axle counters. If the number of axles entering a section equals the number leaving it, then the train must be complete and that equates to Train Out of Section, or train complete leaving the section.

Most of the former Southern Railway tracks in the east of the region are electrified at 750 V DC using a third rail; such tracks are coloured green on the diagrams, while non-electrified tracks are depicted in black. The exception to this is the Isle of Wight, which uses 630 V DC, but the track diagram colour is the same as the higher voltage.

The ways of working so far have only concerned themselves with two parallel Up and Down tracks or multiples of that. Less busy lines can be single track with bi-directional working, which needs special equipment or interlocking.

Single Line Workings

Key Token, No Signaller Key Token, Tokenless Block, One Train Working, One Train Staff. These are covered in detail in the section on the signal box that supervises such workings.

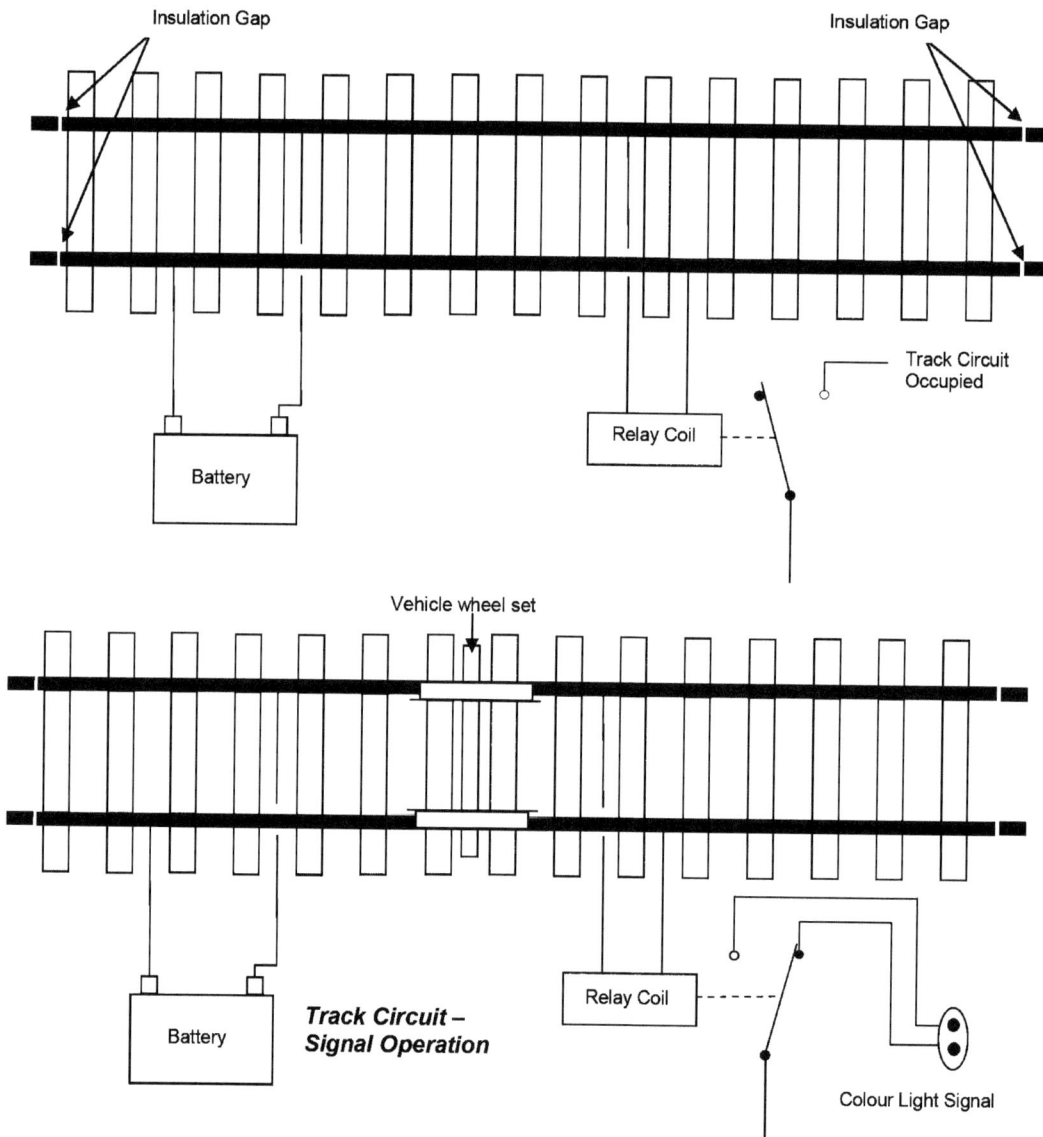

Basic DC current track circuit.

The ways of working are those in operation at the time of the survey with an update as appropriate. Mention of the Great Western Railway is in reference to the company that existed between 1835 and 31 December 1947, rather than the recent train operating company (TOC) of the twenty-first century, unless specifically delineated by the use of the abbreviation GWR.

Summary of Contents

London, Brighton and South Coast Railway (LBSCR)

DORKING TO LITTLEHAMPTON
Dorking
Holmwood
Warnham
Horsham
Littlehaven
Billingshurst
Pulborough
Amberley
Arundel
Littlehampton

SOUTH COAST – BEXHILL to NEWHAVEN HARBOUR
Bexhill
Havensmouth
Pevensey
Eastbourne
Hampden Park
Polegate Crossing
Berwick
Newhaven Town
Newhaven Harbour

SOUTH COAST – LEWES to HAVANT
Lewes
Plumpton
Lover's Walk Depot
Lancing

Bognor Regis
Barnham
Chichester
Havant

Isle of Wight Railway

Ryde St John's Road
Brading

London, Brighton and South Coast Railway (LBSCR)

The LBSCR was often referred to as 'The Brighton Line', which was immortalised in Oscar Wilde's play, *The Importance of Being Earnest*. Lady Bracknell is further outraged at the suggestion that Ernest Worthing not only had mislaid both his parents but was also a foundling, discovered in a handbag at Victoria station – The Brighton Line. The connotation was not lost on the late nineteenth-century theatre goers, who associated the line chiefly with pleasure and, probably, pursuits of an illicit nature.

This popular sentiment of the times was a little wide of the mark, as the LBSCR played its part also in servicing the mass of commuter lines in Sussex, Surrey and part of Hampshire. The railway had first created the means and then reaped the benefits with the commuter concept.

The railway was also the premier means of accessing the south coast resorts of Eastbourne, Brighton, Worthing, Littlehampton and Bognor Regis. The ports of Shoreham-by-Sea and Newhaven were also serviced. It shared access to Hastings, Bexhill-on-Sea and St Leonards-on-Sea with the SECR. The railway's main termini in London were Victoria and London Bridge stations.

The LBSCR spirit has been kept alive by the heritage Bluebell Railway, with many fine examples of buildings, signalling, locomotives and coaches from the old railway.

Dorking to Littlehampton

This journey begins at the commuter town and junction of Dorking and travels over the Sussex Downs to the seaside at Littlehampton. The journey also covers a short excursion towards Three Bridges, the junction with the Brighton Line.

The signalling scene is a mixed one, with more semaphore signalling as we go further south after Horsham – see p. 19.

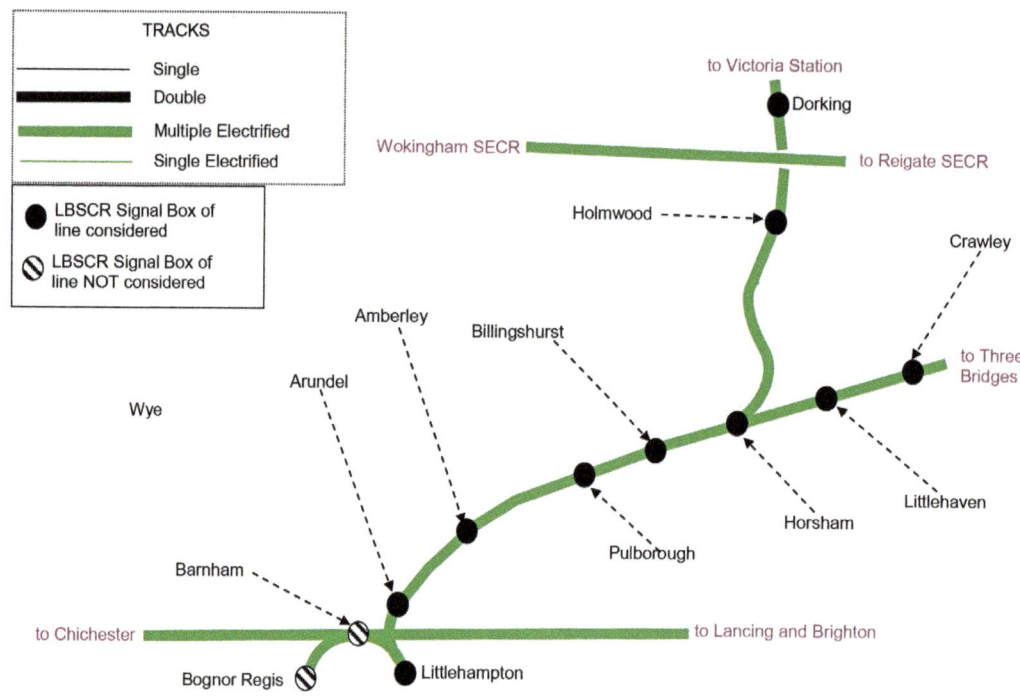

Dorking to Littlehampton

Dorking (CBK)

Date Built	LBSCR Type or Builder	No. of Levers or Panel	Ways of Working	Current Status (2016)	Listed Y/N
1929	Southern Railway Type 13	44	TCB/AB	Active	N

In the county of Surrey, Dorking is a market town attractively situated on the North Downs; the station has a poster that announces that you have arrived at the Surrey Hills. The LBSCR station, whose present signal box was originally named Dorking North, has services to both Victoria and Waterloo and our modern passenger numbers of 1.29 million were also, to some extent, anticipated and generated by the Southern Railway in their electrification of the line to London in 1925. However, steam services to Horsham and beyond lasted until 1964.

Dorking signal box is 22 miles 1 chain (35.43 km) from Waterloo via Worcester Park.

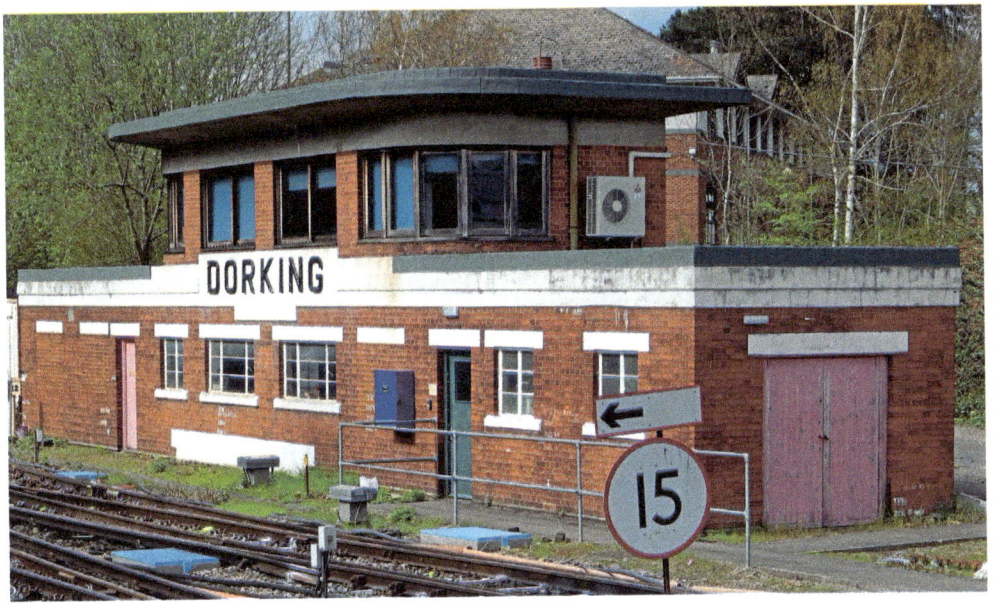

The Art Deco period gained momentum in the 1920s, and the Southern Railway was never reluctant to present a modern face to the public. The box also had its practical side, with a large area underneath the box for the Signalling and Telegraph (S&T) department as well as a set of double doors to facilitate the movement of heavy equipment in and out. This type of box is referred to as either Queen Mary (as in ship) or Odeon style, as both were products of the 1930s, the latter being a cinema chain.

The box is equipped with the Southern Railway standard lever frame, manufactured by the Westinghouse Brake & Signalling Company at Chippenham. Despite the relative modernity of the box, in absolute block days the instruments were of nineteenth-century manufacture. April 2016.

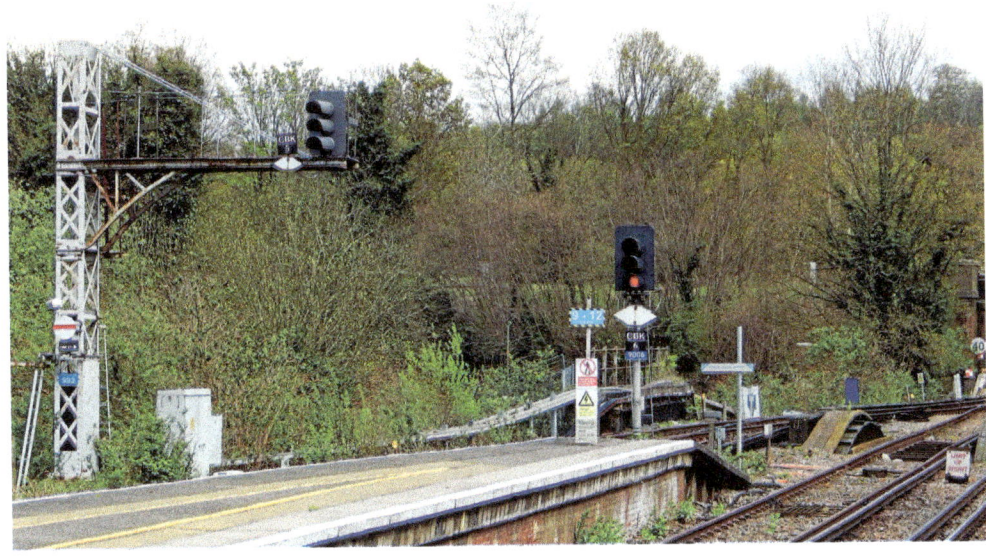

Dorking station looking towards Horsham. Points of interest are an elevated ground disc with floodlight on the extreme left, and a limit of shunt indicator on the extreme right. April 2016.

15

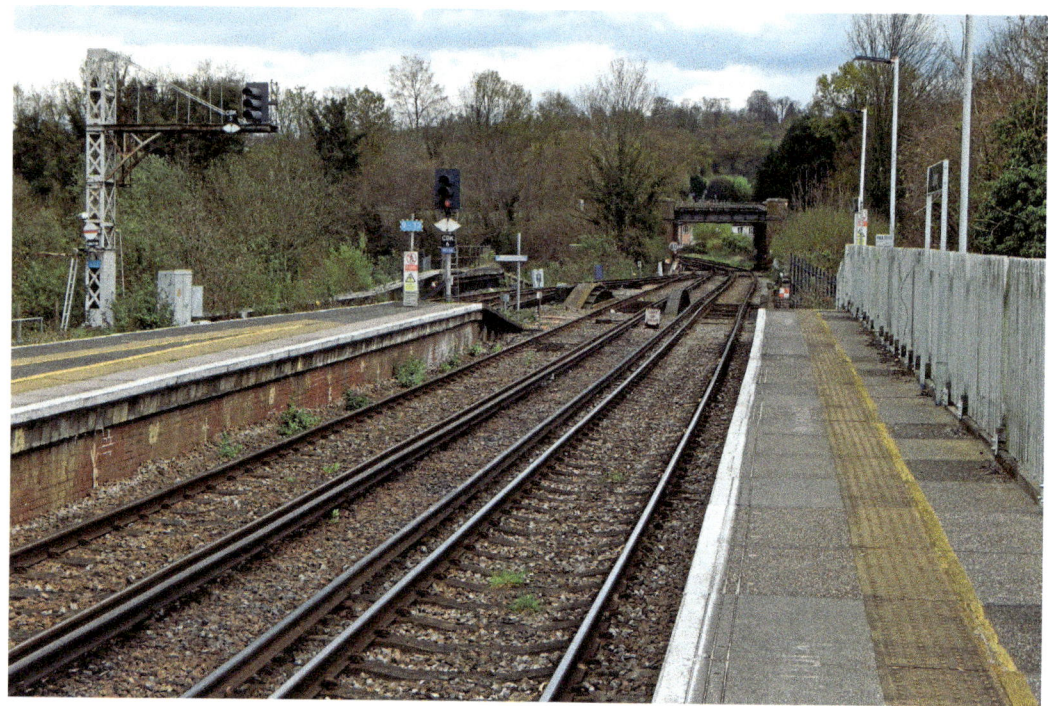

The SECR line from Wokingham to Reigate is in the background. Dorking Deepdene and Dorking West stations are SECR territory, and there is no rail connection between this station and the others. April 2016.

Holmwood (--)

Date Built	LBSCR Type or Builder	No. of Levers or Panel	Ways of Working	Current Status (2016)	Listed Y/N
1877	Saxby & Farmer Type 5 (LBSC)	18	AB pre 2005	Closed	Y

Into the county of West Sussex and the line from Dorking and beyond is termed the Sutton and Mole Valley line and Holmwood is a station that serves two villages. South Holmwood and Beare Green generate some 53,000 passengers a year.

Holmwood station is 27 miles 5 chains (43.55 km) from Waterloo via Worcester Park.

The signal box was thought to be sufficiently early and in original enough condition to warrant listing. The later LBSCR style was quite different and was even more ornate in certain cases. The box had a plethora of Southern Railway block instruments and other indicators in absolute block days, as recently as 2005. The figure shows the box at the end of the platform but the platforms here have latterly been extended to accommodate longer trains. June 2008.

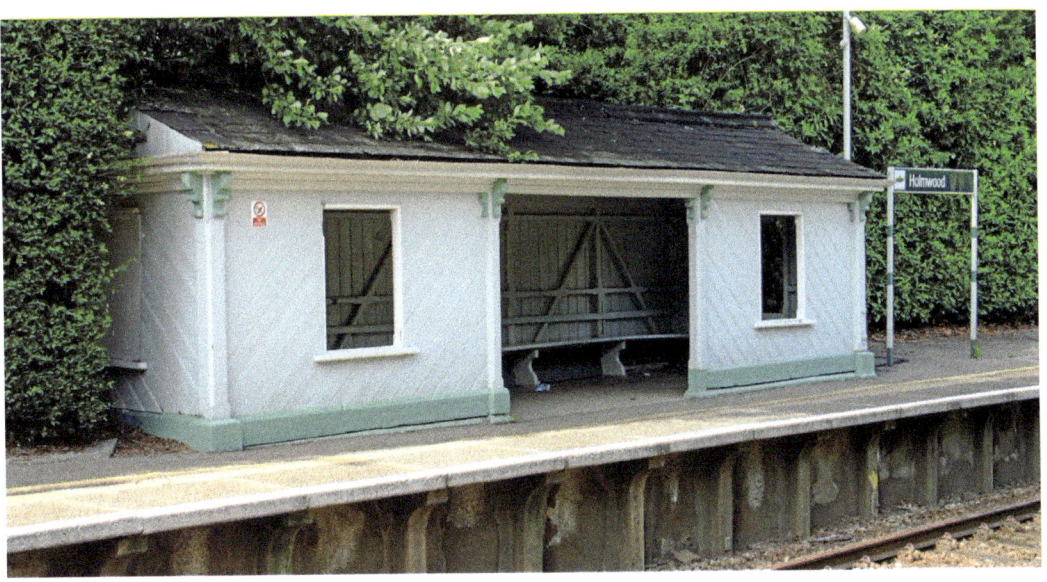

This charming wooden waiting shelter is an LBSCR structure and is seemingly only minus the window frames from the original. The wooden bench seat is fairly simple in its construction but functional, while the cladding is attractively diagonal at the front and sides, and vertical at the rear. June 2008.

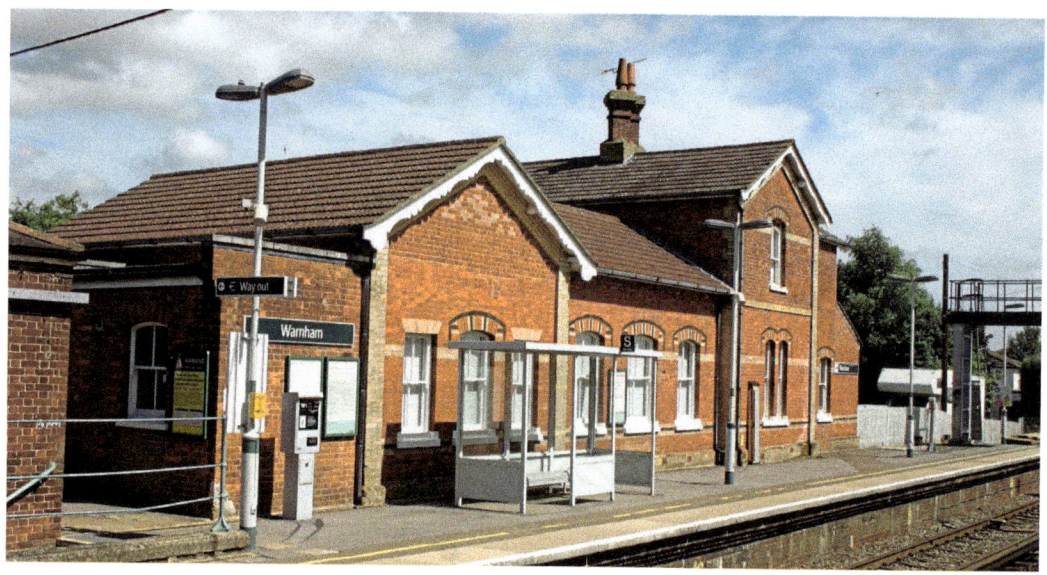

This is the small country station building at Warnham. Note how even the smaller building has ornate brick arches over some of the windows and scalloped bargeboards. The bracket signal on the platform is controlled by Three Bridges Area Signalling Centre at the survey date. June 2008.

A similar box existed at Warnham further down the line towards Horsham but was demolished by the time the survey took place in 2008. It had been an absolute block post, but was then just a gate box; finally, the road crossing became 'restricted access' and so the gate box was no longer needed.

Warnham station is 33 miles 46 chains (54 km) from Waterloo via Worcester Park.

Horsham (–)

Date Built	LBSCR Type or Builder	No. of Levers or Panel	Ways of Working	Current Status (2016)	Listed Y/N
1938	Southern Railway Type 13	90	TCB/AB	Closed	Y

Horsham is a pleasant market town near the source of the River Arun, and we shall come across this waterway later in the journey. Horsham is the junction with the line to Three Bridges and we shall be taking a short excursion up it towards Crawley and Gatwick Airport. In addition to the Three Bridges route to Brighton, there was also a more direct route through the delightfully named Partridge Green to a junction near Shoreham and another branch line to Guildford. Both branches made Horsham a considerable junction, and the steam shed was coded 75E as a sub shed to Three Bridges under BR. There are still sidings and track maintenance facilities resembling something of a freight yard here.

There are two mileages given for Horsham signal box: 37 miles 40 chains (60.35 km) from London Bridge station and 35 miles 35 chains (57.03 km) from Waterloo station.

The journey takes a diversion up the line towards the Three Bridges direction.

This illustrates the Southern Railway 'Odeon' or Art Deco style of signal box; this consisted of a large ground floor with accommodation for the Signalling and Telegraph (S&T) equipment and technicians, and a smaller upper floor with the rounded corner brickwork. The window details are concrete beams. Despite the relative modernity of appearance, there is still a coal stove chimney. Since closure the box still retains its accommodation for the S&T department. Note the post with '37' and two markers below it. This refers to the mileage of 37 miles 40 chains (60.35 km) from London Bridge station. March 2016.

The yard at Horsham not only accommodates track maintenance vehicles, but also all manner of civil engineering supplies such as ballast, concrete sectional signalling wiring troughs, waste water pipes and chemical tanks. The small, brick-built structure in the middle of the picture would appear to be a 'privy' or WC. The lines on the left lead back to Dorking and on the right to Three Bridges, where we are headed for next. March 2016.

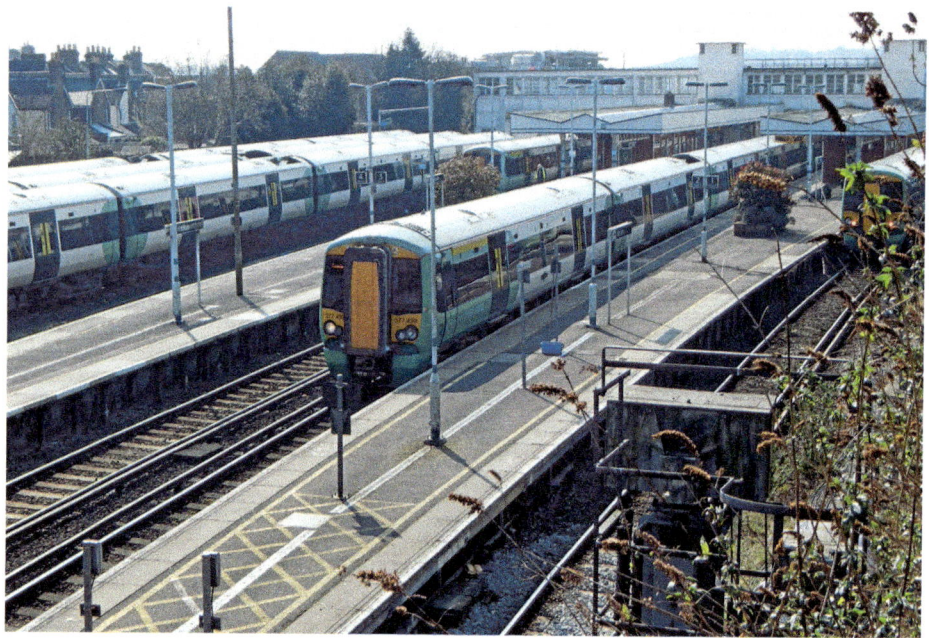

The other side of the bridge from where the previous figure was taken is the station at Horsham, which is busy even in the middle of the day, with three out of the four platforms occupied. Three out of the five carriage sidings are also occupied, beyond the platforms, and they are also the only electrified ones. March 2016.

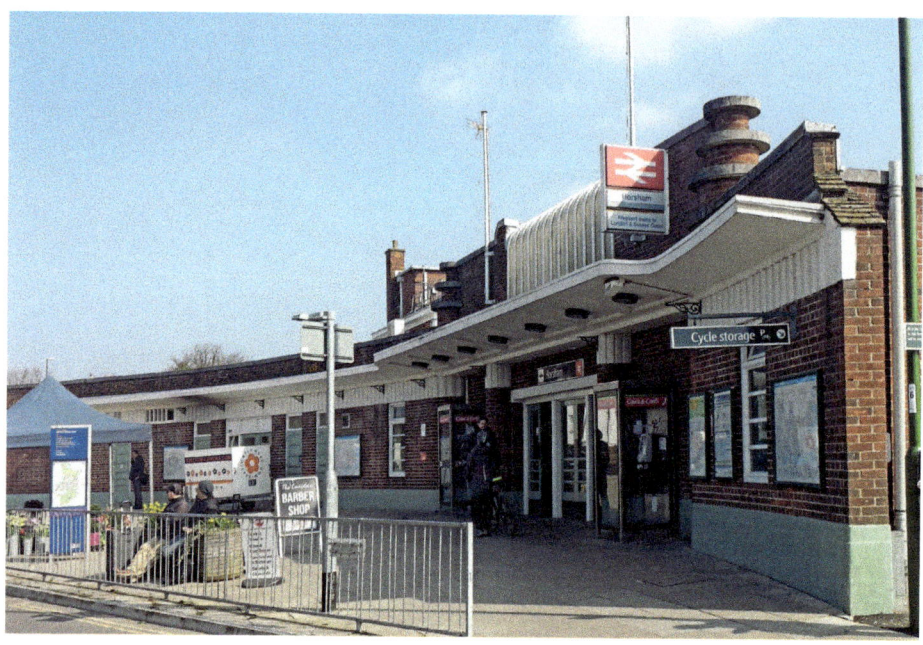

The Art Deco Horsham station building has the original entrance doors, by the look of it. The curved shape of the building and the use of rounded corners and decoration make the building interesting and attractive. March 2016.

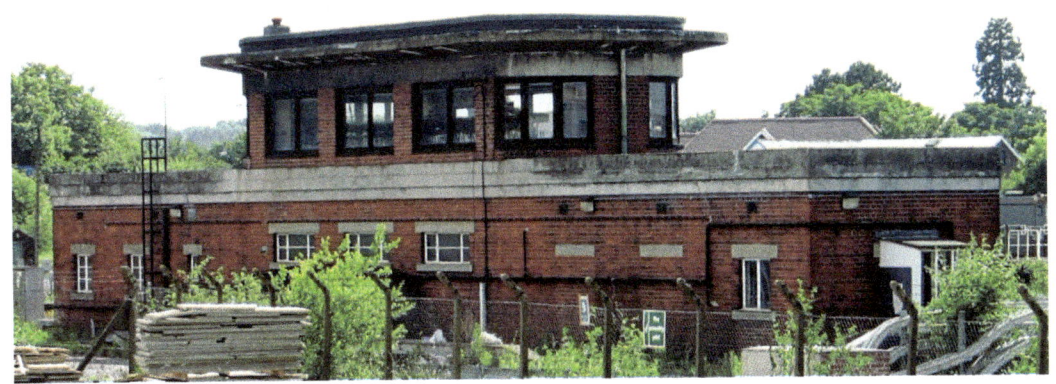

The earlier rear view of Horsham signal box shows part of the ninety-lever frame and the 'block' shelf above it. June 2008.

Littlehaven (--)

Date Built	LBSCR Type or Builder	No. of Levers	Ways of Working	Current Status (2016)	Listed Y/N
1938	Southern Railway Signal Box & Booking Office	8	Gate	Closed	N

Littlehaven is regarded as a district of Horsham but is a more rural environment.

The station lacks a booking office and station building as such, as the signal box combined the functions of working the crossing gates and issuing tickets to passengers. The railways sought to cut costs, particularly after the First World War, and small wayside stations would often employ a porter/signaller, who would attend to passengers' needs as well as the trains. There are examples of a single siding for a goods yard coming under the same responsibility.

The mileage changes again and Littlehaven station is 36 miles 50 chains (58.94 km) from London Bridge station via Redhill.

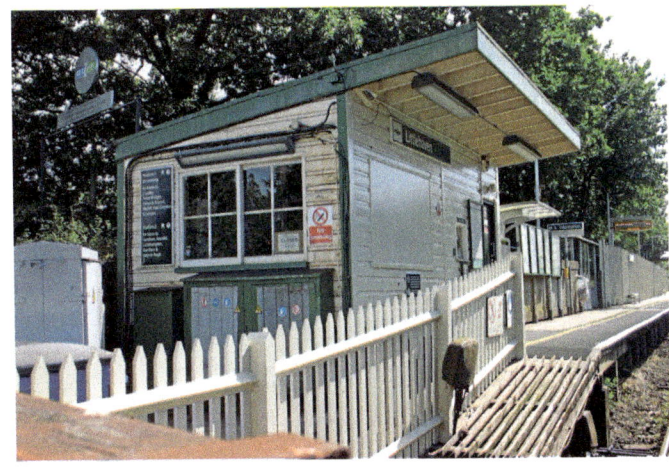

Littlehaven signal box and booking office from the road crossing; the sign in the window says 'Ticket Office Closed'. The functions of the signaller would be made redundant by the advent of automatic full barriers and the ticket clerk by a platform-mounted machine. June 2008.

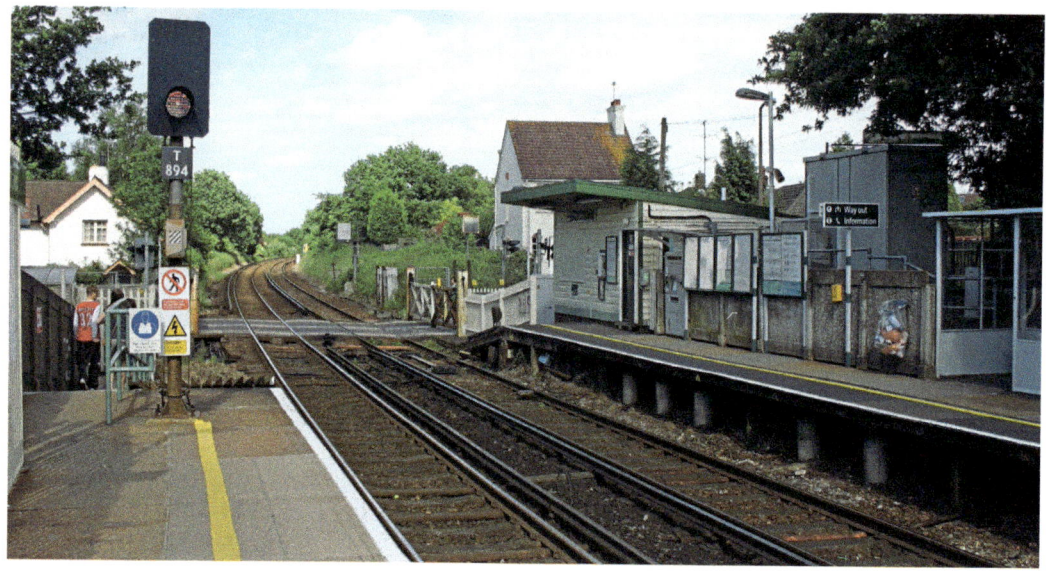

This shows Littlehaven station platforms and gates, and the only visible update to this scene in 2016 is the replacement of the gates by barriers. The Three Bridges LED colour light signal bears testament as to the fate of the signal box signalling. June 2008.

Crawley(--)

Date Built	LBSCR Type or Builder	No. of Levers or Panel	Ways of Working	Current Status (2016)	Listed Y/N
1877	Saxby & Farmer Type 5 (LBSC)	21	AB	Closed	Y

Crawley has ancient roots but developed rapidly as a new town after the Second World War, and even more so with the development of Gatwick Airport, which had previously been a horseracing track.

Three Bridges Railway Operating Centre (ROC) is in Crawley and was opened in 2014. It will control a good deal of the south coast and its connecting lines.

Crawley station is 36 miles 50 chains (58.94 km) from London Bridge station via Redhill. The journey continues on the Sussex Downs towards the south coast and Littlehampton.

22

Crawley signal box is in the care of the Crawley Signal Box Preservation Society and is a credit to them. The station had been moved a short way up the line towards Three Bridges. June 2008.

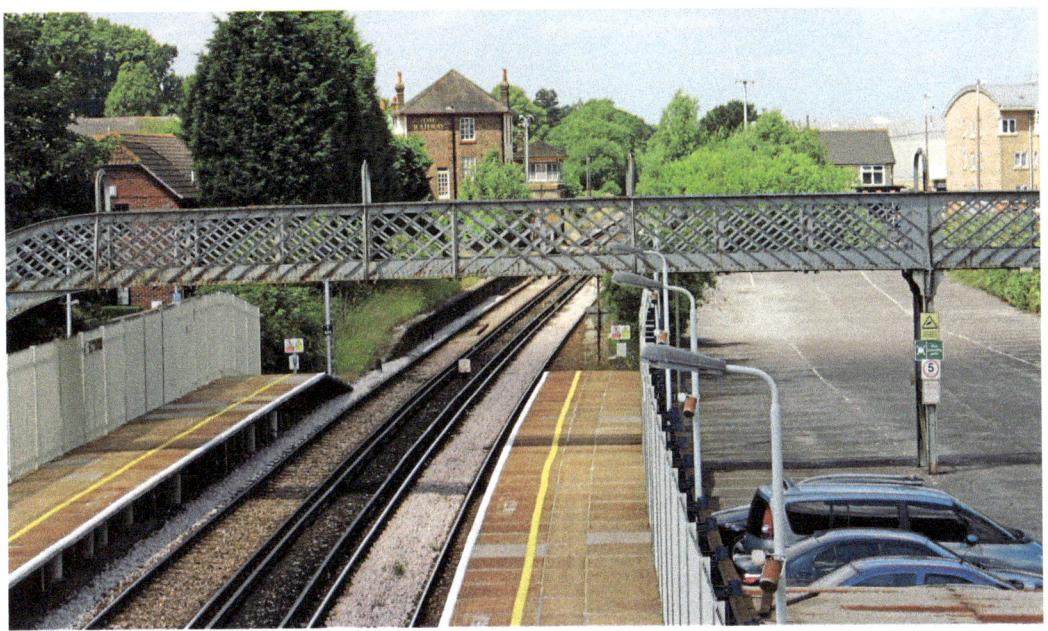

Crawley station: the view is from the more recent version of Crawley station, while the overgrown platform of the original is still visible. The signal box is beyond the old platform. June 2008.

Billingshurst (BT)

Date Built	LBSCR Type or Builder	No. of Levers or Panel	Ways of Working	Current Status (2016)	Listed Y/N
1876 circa	Saxby & Farmer Type 1b (LBSC)	19	AB	Removed to Amberley	Y

Billingshurst is a pretty village in West Sussex that continues to prosper with its station and rail connections. The signal box is a very early survivor and is all the more remarkable because it is built chiefly of wood. The box was removed to a nearby railway museum in March 2014.

Billingshurst station is 44 miles 71 chains (72.24 km) from London Bridge station via Redhill.

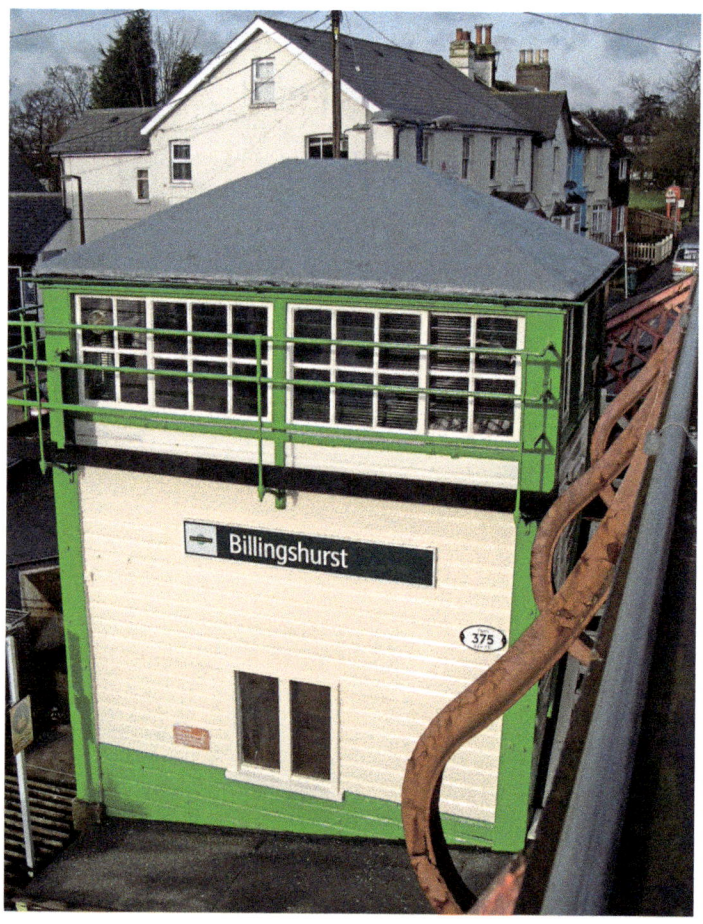

This view sees Billingshurst signal box still hard at work as an absolute block post. It is substantially original after over 130 years' service. The station footbridge from which the view was taken seems to be the same age. The box was thought to have been brought here from somewhere else in 1876, and the design indicates it was manufactured in 1866, which, if that were true, would have made it the earliest signal box on Network Rail. January 2006.

24

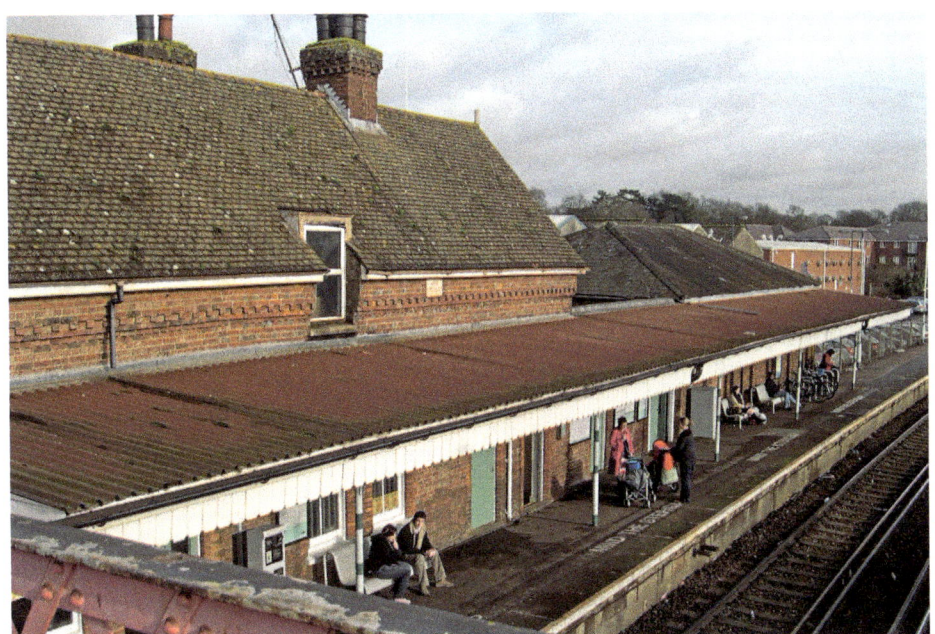

Although the LBSCR built larger stations for glory, and to impress, the smaller units were more modest and built alongside the goods shed as here, where the goods shed seems to share part of the platform canopy. The platform is in the Up direction towards Horsham. January 2006.

The goods yard has been reduced to a car park as in so many instances, but the goods shed survives in business use with its windows intact. The starter signal on the Up platform can be seen and the Down platform signal was a colour light signal at the survey date. January 2006.

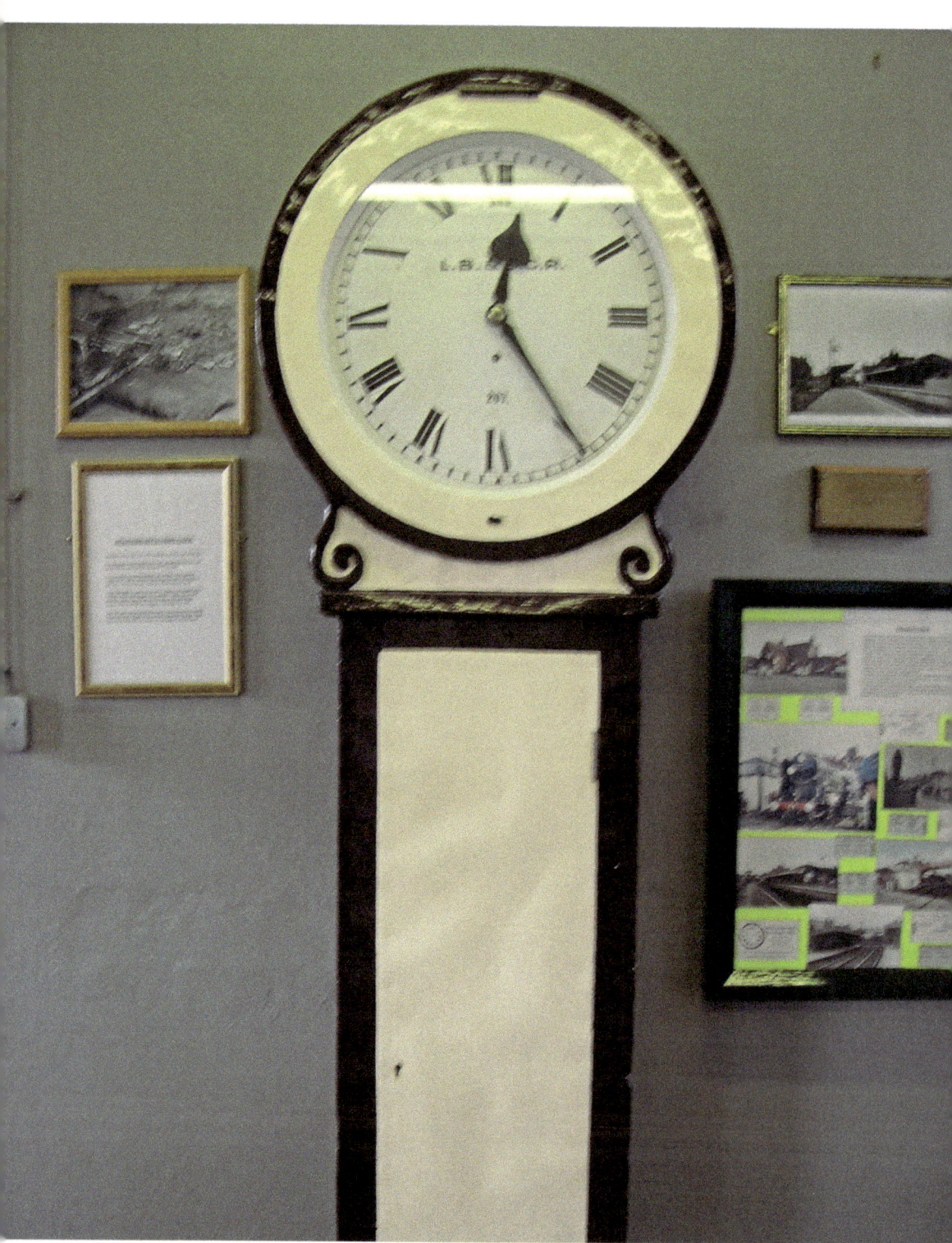

The LBSCR clock and display of steam age photographs was in the booking hall at the survey date. January 2006.

Pulborough (PH)

Date Built	LBSCR Type or Builder	No. of Levers or Panel	Ways of Working	Current Status (2016)	Listed Y/N
1878	Saxby & Farmer Type 5 (LBSC)	30	AB	Closed	Y

The station was once the junction for a branch line that ran to Midhurst and then ambled down to Chichester. The branch closed to passengers in 1955 and goods in 1964.

Pulborough signal box is 49 miles 74 chains (72.24 km) from London Bridge station via Redhill.

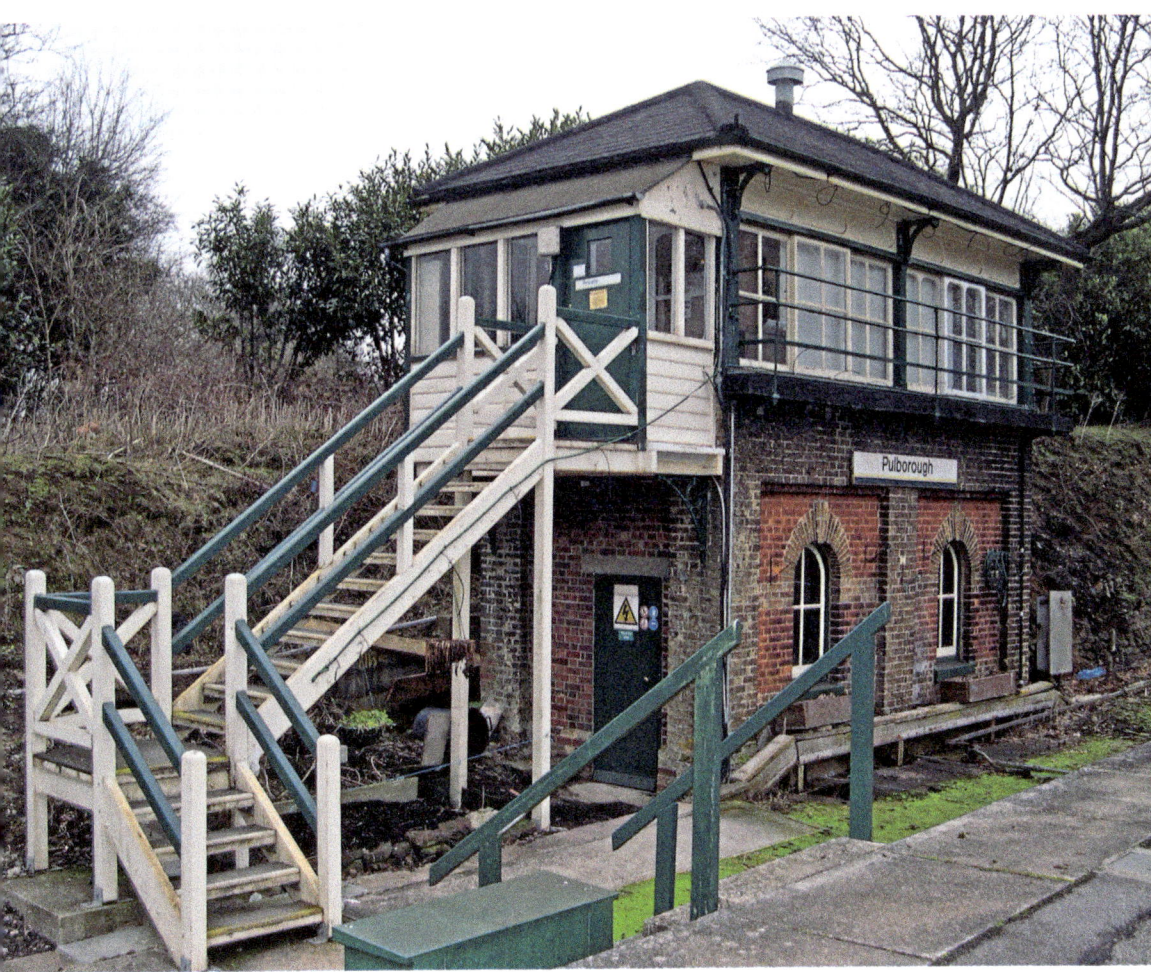

This depicts a much larger brick-built structure at Pulborough than Billingshurst and there is age to the box. The LBSCR built the staircase in the Dreadnought battleship style, and clearly any Network Rail galvanised steel-grey version would be a retrograde step or steps. The LBSCR style of the large overhanging eaves anticipated the current vogue for some sort of sun screening above the windows. The locking-frame window detail is reproduced in full with charming brick arches surmounted by keystones or key bricks. January 2006.

All aspects are pleasing at Pulborough signal box, and there is evidence of gardening in the window boxes and hose pipe. January 2006.

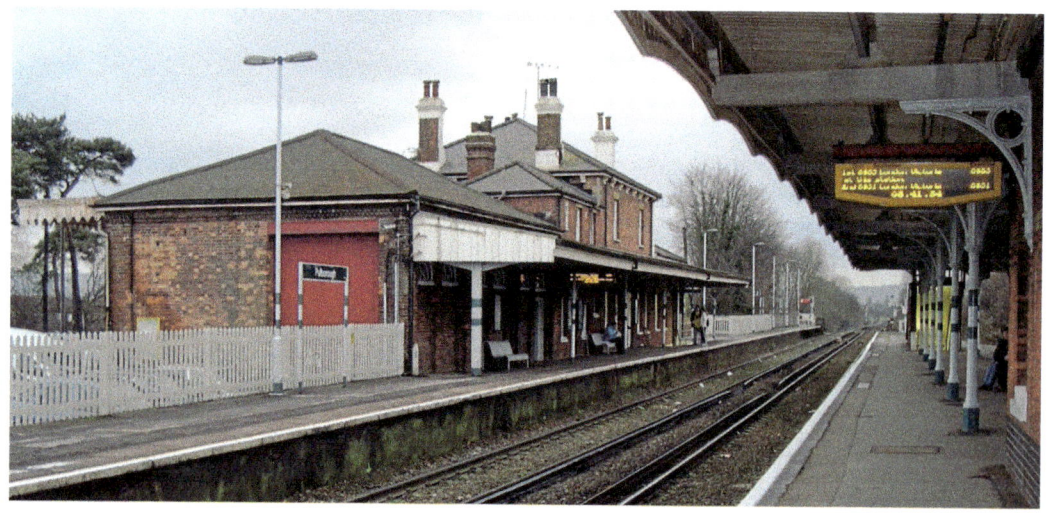

The station building and goods shed are in the same semi-detached style we saw at Billingshurst, and to the same level of originality. This view is towards Amberley and Littlehampton and is from the island Platform 1. The Midhurst branch line trains ran in on the opposite platform face, to the extreme right, and terminated at Pulborough around the Second World War rather than running through to Horsham. January 2006.

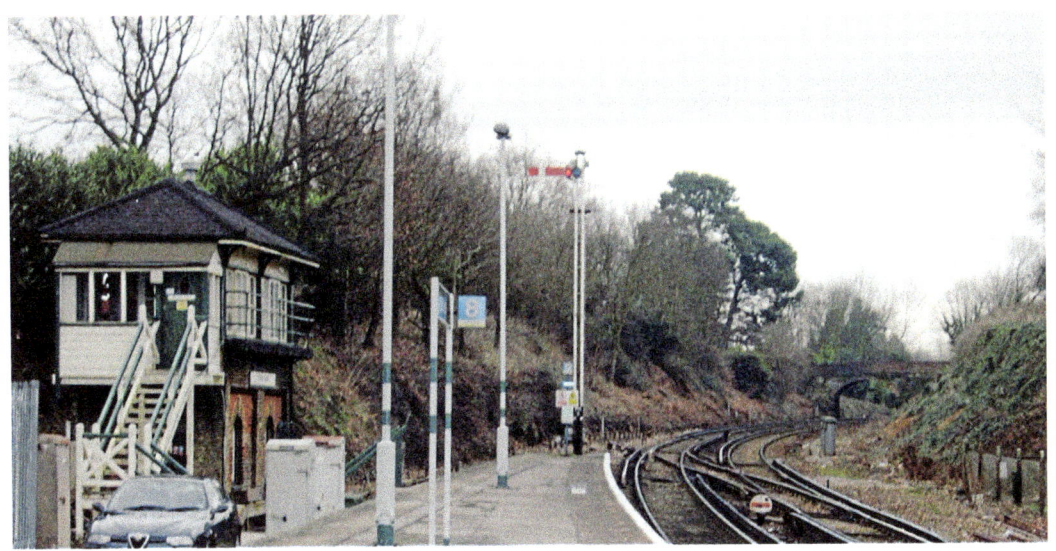

This is the view towards Horsham, still on the island platform, and the Midhurst loop platform line ran where the signaller's car and grey equipment cabinets now are. The goods yard sidings were opposite the signal box on the Down side towards Amberley. The tall signal post affords a view of the arm above the island platform canopy and the ground signal controls reversing moves over the trailing crossover from Down to Up lines. As with Billingshurst, at the survey date, the trailing crossover is all the point work there is here. January 2006.

The station overview from the Down Platform 2 highlights the handsome scalloped valance on the platform canopy and the subway rather than footbridge. January 2006.

29

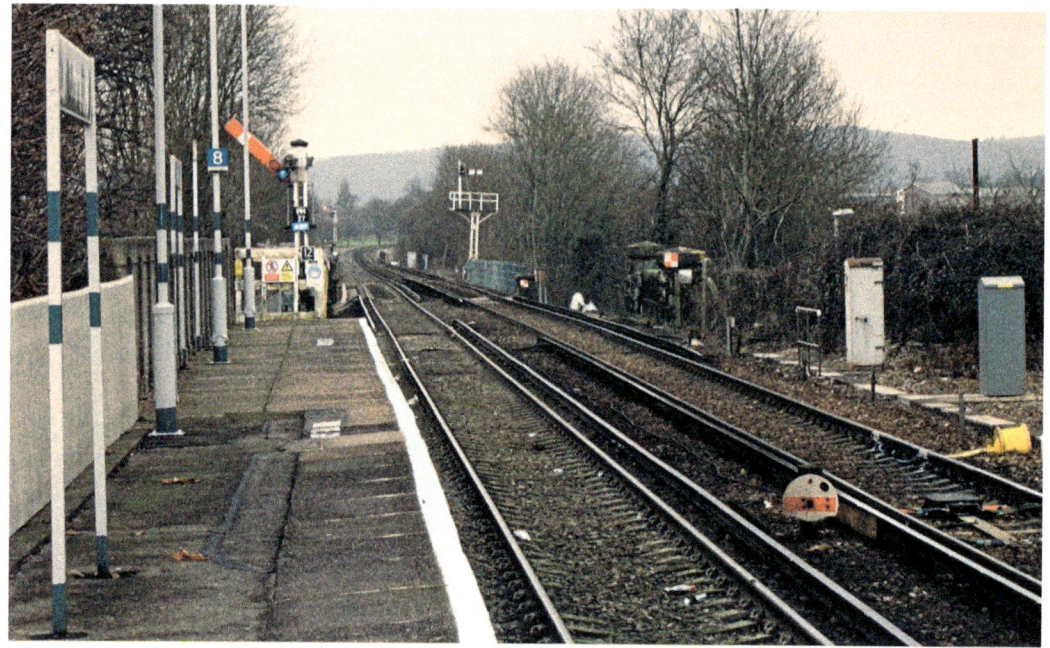

In the distance is one of the ups of the Sussex Downs, which invites progress towards Amberley and the coast from the Down platform, and a train will shortly be exploring that territory. The Up signal hints at a further arm on the bracket to signal trains into the Midhurst loop platform and the point left the main line for the loop platform just after the River Arun viaduct, where the grey equipment cabinets are. The yellow flange greaser prepares the wheel flanges for the sharp curve by the signal box up ahead. January 2006.

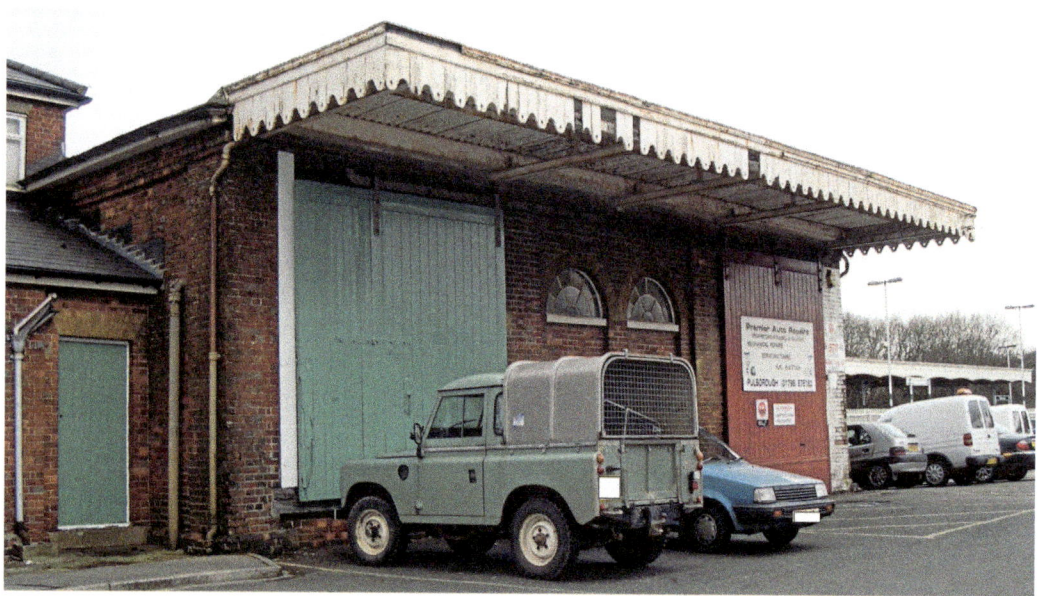

Pulborough goods shed looks as though it could still accept freight for onward movement although it shares Billingshurst's fate in catering for the car's needs. January 2006.

Amberley (AY)

Date Built	LBSCR Type or Builder	No. of Levers or Panel	Ways of Working	Current Status (2016)	Listed Y/N
1950s	Booking Office & covered lever frame	14	AB	Closed	N

Amberley is another Sussex Downs village, located near the defunct Amberley Chalk Pits. This location provides the base for a museum of transport and social history, which features a narrow-gauge railway. Amberley Chalk Pits were the recipient of Billingshurst signal box, which we saw earlier in the journey.

Amberley signal box is an oddity in that, for years, it was an external ground frame but was later covered in by a shed-like structure.

Amberley station is 54 miles 62 chains (88.15 km) from London Bridge station via Redhill.

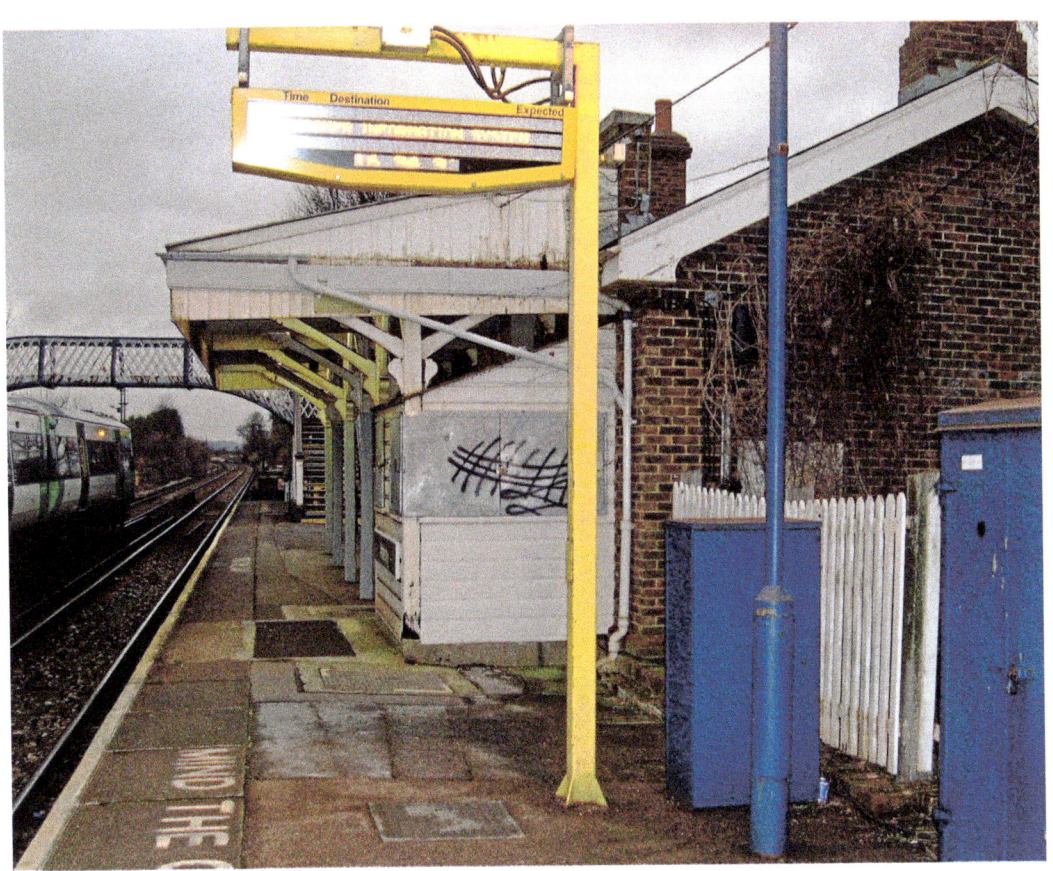

This view shows the graffiti-daubed Amberley signal box with the shutters up. This would seem to be the usual operating posture in later years, as the box was almost permanently switched out. The signal box had doubled as a booking office, as with Littlehaven earlier in the journey. A Class 377 EMU sails past the Up starter signal at Platform 1 towards Horsham. January 2006.

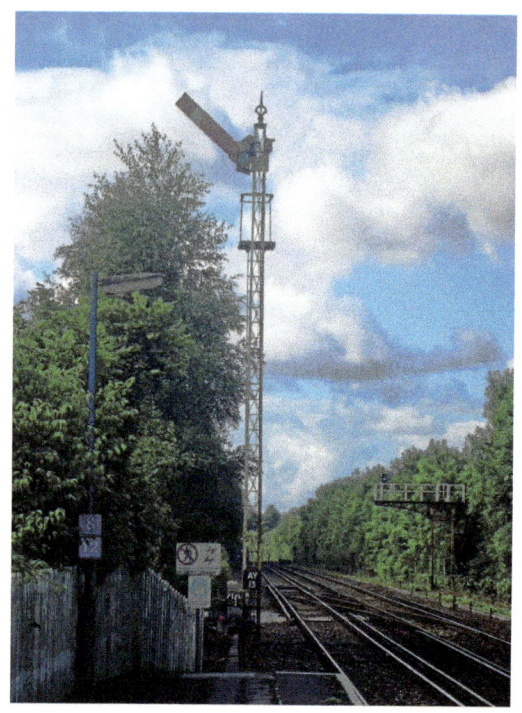

Left: Pictured is the view towards Arundel and Littlehampton, and both signals are off as the box is switched out. Switched out means that its functions are bypassed and the block section then becomes Pulborough to Arundel. The trailing crossover points are the only ones at this location. June 2006.

Below: This is the starter signal for the route to Horsham for Up trains, which is also off; it is framed by the venerable footbridge of the type we glimpsed at Billingshurst. The bridge girders just past the platform make up the structure to carry the railway over the station approach road. June 2006.

A Class 377 rolls to a halt at Platform 1, bound for Horsham. The station buildings are unpretentious and economical. January 2006.

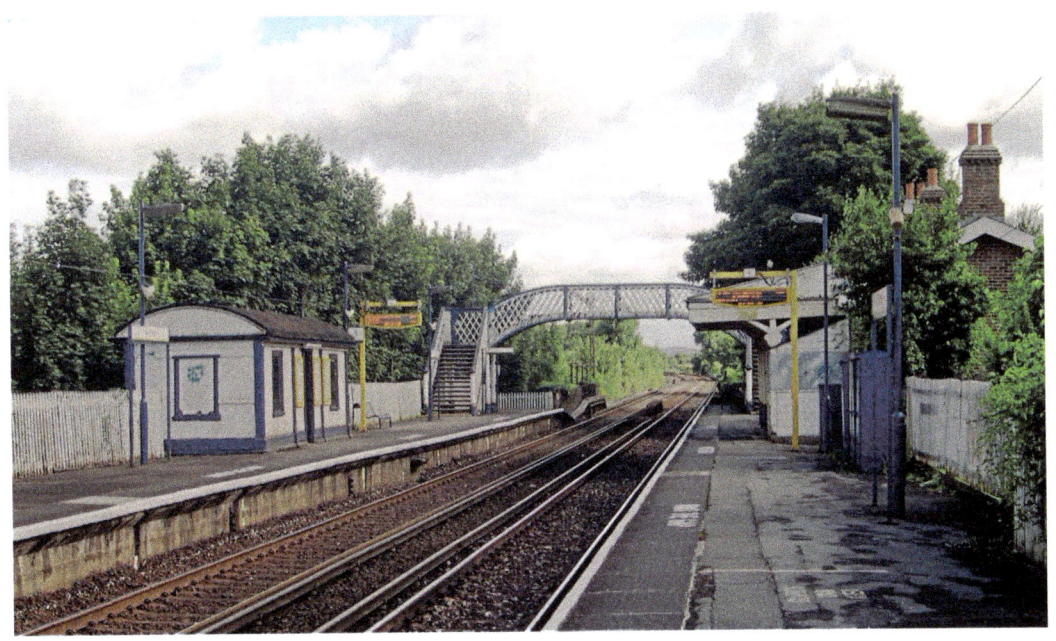

This is an overview of Amberley station, with an LBSCR waiting shelter with diagonal lap boarding and a curved roof. January 2006.

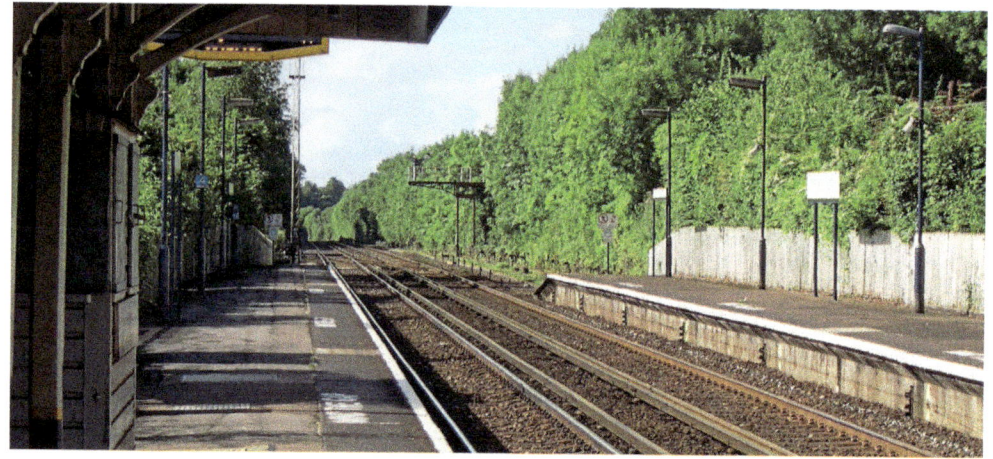

The final view towards Arundel and the lattice post signal arm must be able to be seen over the top of the canopy. The Up section bracket signal has no such issues with the small shelter. The signal box is on the left. January 2006.

Arundel (AR)

Date Built	LBSCR Type or Builder	No. of Levers or Panel	Ways of Working	Current Status (2016)	Listed Y/N
1938	Southern Railway Type 13	Nx Panel	TCB/AB	Active	N

The town lies at the mouth of the River Arun and is dominated, geographically at least, by Arundel Castle – the ancestral home of the Duke of Norfolk. Consequently the town sees tourist traffic as well as commuters.

Arundel signal box is 58 miles 36 chains (94.1 km) from London Bridge station via Redhill.

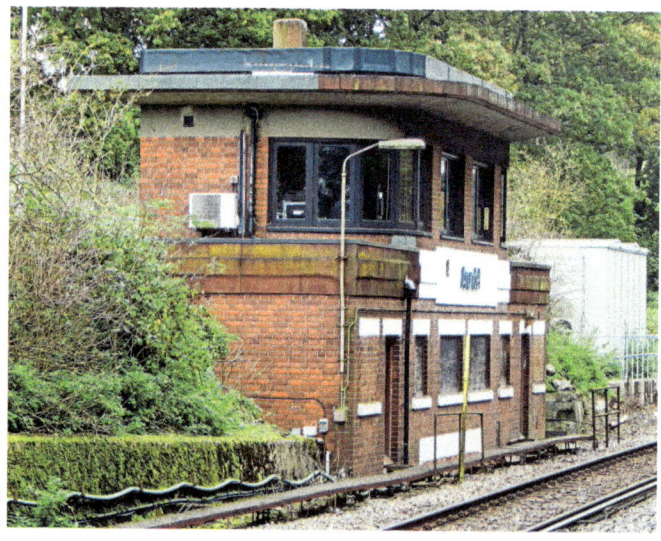

Arundel signal box was a rather avant-garde structure in the 1930s, considering the ancient nature of Arundel Castle and the town. October 2015.

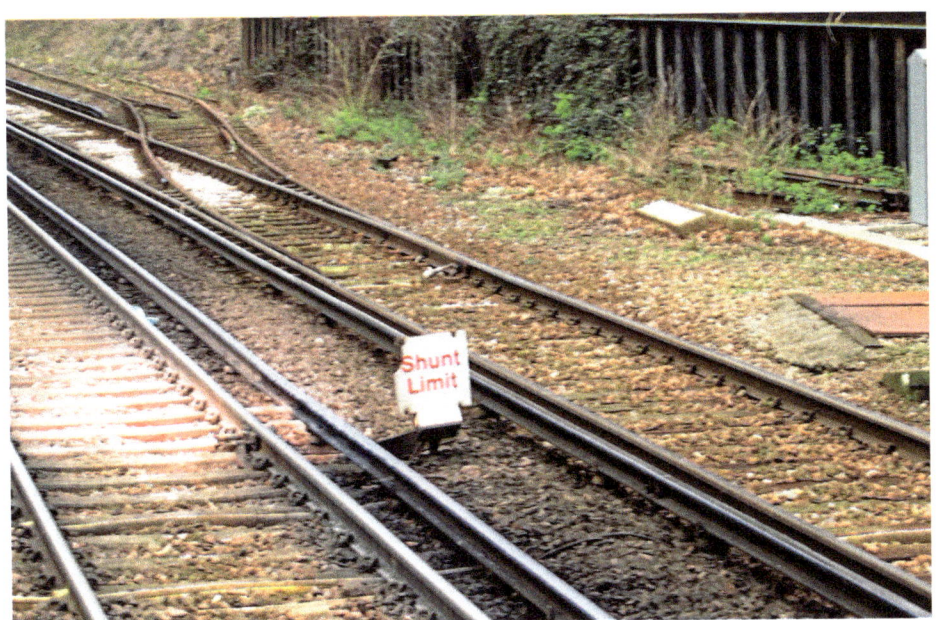

Pictured is a shunt limit indicator to signal to a train driver that incursion beyond the sign means illegal or un-signalled entry into the next section. The sign would appear to refer to the use of the trailing crossover in the opposite direction. The Up siding, so called, appears to be out of use, with no visible means of changing the point or trap point over, and the running rail point blade appears to be spiked or clamped in position. There is also no signal to control a train's exit from the siding; it would need hand signals, flags or the Bardic lamp from the box, which is nearby. January 2006.

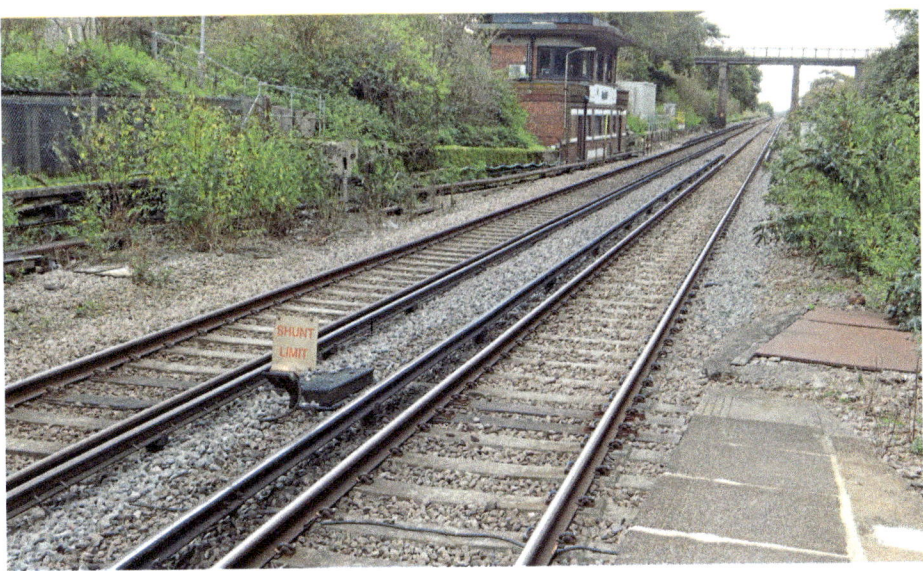

The view on the later survey reveals that the siding and trap point have been removed but the shunt limit sign remains as that is concerned with movements on the running lines. October 2015.

35

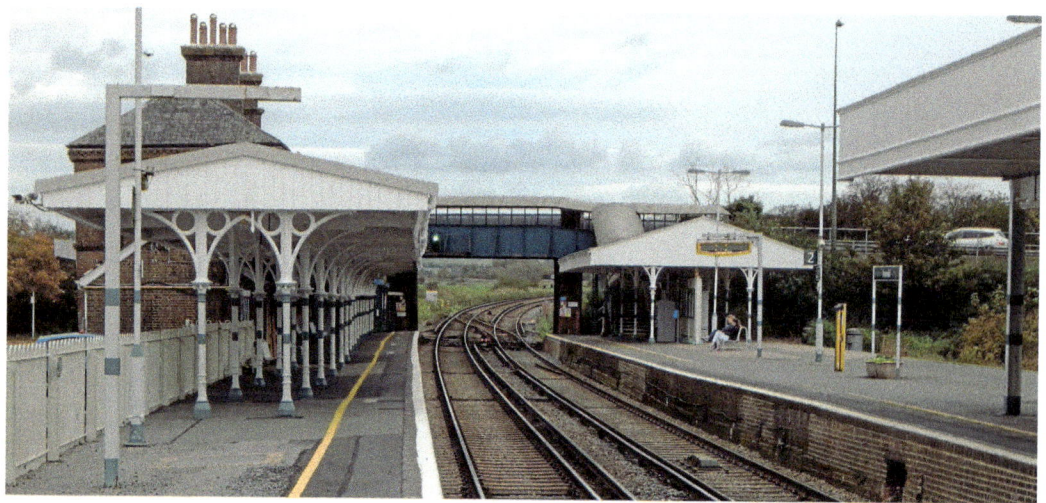

This is a view a bit further down the Up platform from the previous view to the imposing Grade II listed goods shed. The LBSCR parentage of the fanlight windows we saw at Pulborough and Billingshurst is clearly evident, and the wooden doors and office door on the right look in keeping with the original building. January 2006.

The view here depicts the way clear towards Horsham with the colour light signal suspended from the footbridge clear of the LBSCR cast-iron columns of the Platform 1 canopy. The ironwork is copied on Platform 2 opposite, and this structure was also the location for Platform 3 on the far right. October 2015.

36

Class 377 No. 377408 arrives at Platform 1 with a service for Horsham and beyond. Note the distinct differences in the canopies between Platforms 1 and 2. The Platform 2 type may be a Second World War Southern Railway addition. October 2015.

The station building at Arundel is surprisingly modest, given that the Duke of Norfolk lives just up the road. January 2006.

37

Littlehampton (LH)

Date Built	LBSCR Type or Builder	No. of Levers or Panel	Ways of Working	Current Status (2016)	Listed Y/N
1886	LBSCR Type 2a	44	AB	Active	N

This journey's end at Littlehampton ends up at the mouth of the River Arun at a pleasant seaside resort, harbour and commuter town. Some of the town's Regency terraces by the sea front are listed buildings.

Littlehampton signal box is 61 miles 69 chains (99.56 km) from London Bridge station via Redhill.

Above: The Littlehampton signal box has the extraordinary addition of what appears to be a platform canopy valence added to the gutter line. Perhaps this was to minimise the effect of the strong summer sun. The LBSCR looking stairway has been retained although appears to be a modern replacement done at the same time as the addition of the small toilet block. Note the Network South East-style nameplate. July 2015.

Opposite above: This not only gives a side view of the box but also a look at the Platform 1 and 2 signals for Littlehampton station. Although modernised, there is no mistaking the Southern Railway parentage of the rail-built signal post and brackets. July 2015.

Opposite below: Platforms 3 and 4 are considerably shorter than 1 and 2 and consequently their starter signals are much nearer the station building. The carriage cleaning and servicing area is on the extreme left. The signals have a similar configuration to Platforms 1 and 2, even down to the ground signal lights. There is also carriage window cleaning equipment on the platforms. July 2015.

39

Platform 2 and a Class 377 has the off signal twice in the sense that the semaphore is clearly off but the repeater caption box in front of the driver's cab also says 'OFF'. July 2015.

The carriage or EMU servicing facilities at Littlehampton are modernised, as are the main-line running signals. The digital caption to the left of the 70 mph sign appears to be a speed readout for drivers in the servicing area, which is no doubt recorded. The view is towards Arundel. Colour light signals take over from where the carriage shed is. July 2015.

The camera swings around 180 degrees from the previous figure and the layout of Littlehampton station is partially revealed. The grassy right-hand side was the site of the goods yard and shed, but now accommodates the carriage washer line. The pair of white-railed crossovers allow any arriving train to access any of the platforms. July 2015.

Back down to earth and the rest of the station layout platforms come into view – note how short the far platforms are. July 2015.

41

The end of the journey at Littlehampton station, with three of the four platforms occupied. From left to right: Platform 3, No. 377462; Platform 2, No. 377406; Platform 1, No. 313208. Note how the caption box OFF indicator positions are configured for four coach sets. When the signal is on or at danger, there is no indication from the caption box. July 2015.

The goods shed at Littlehampton didn't fare as well as Arundel and was no longer there on the subsequent survey in 2015. January 2006.

Signals 32 and 30 are right by the box, and the signal number usually means the number that the lever that pulls it is in the frame. The disc signals for the carriage sidings are not so honoured. The disc for signal 30 is lever 31 and the disc for signal 32 is lever 41 in the frame. The ground signals control entry into the carriage cleaning and servicing shed yard; they are illuminated by separate lamps, despite having the usual red and blue spectacles. The GSM-R telephone number for the box is another modern feature and, although the train driver could theoretically call out, the purpose of GSM-R is also to act as a recorder of what has passed between signaller and train driver. The overall move is towards aircraft-style data and voice recorders to aid an investigation in the event of a mishap. Network Rail grey is the colour for ironwork and fittings now that steam locomotives no longer make it all black. July 2015.

South Coast – Bexhill to Newhaven Harbour

We pick up this journey just down the coast from Bopeep Junction on the SECR. The coast is peppered with well-known seaside resorts, most notably Eastbourne, as well as the major conurbation of Brighton. The line heads west to Newhaven, where the LBSCR sought its share of the lucrative cross-Channel ferry traffic.

Depicted overleaf is the schematic diagram for the journey, and we begin at Bexhill-on-Sea in the county of East Sussex. The south coast lines are known as the East and West Coastway Line for marketing purposes.

South Coast – Bexhill to Newhaven Harbour

Bexhill (CCW)

Date Built	LBSCR Type or Builder	No. of Levers or Panel	Ways of Working	Current Status (2016)	Listed Y/N
1876	Saxby & Farmer Type 5 (LBSCR)	19	AB	Closed 2015	Y

The local nabob, the Earl de la Warr, converted Bexhill from a village into a town in the early nineteenth century, and the railways did the rest in terms of the successful seaside resort it became. The SECR also reached the town from the north from a junction at Crowhurst, about 3 miles (5 km) from Bopeep Junction. The SECR Bexhill West station building survives as a Grade II listed structure, although it is no longer in railway use.

Bexhill signal box is 29 miles and 61 chains (47.9 km) from Brighton station.

Opposite above: Bexhill signal box is fairly original; it retains a chimney stack and pot, and the box seems to be built into the wall behind. The chimney stack is built from the same type of bricks as the wall, while the box bricks are different. The low stature of the box is presumably to aid the view up the Down platform under the canopy. Note the consequently diminutive locking frame windows. The Network South East (NSE) name board and galvanised steps are more modern features. June 2008.

Opposite Below: This is the Up starter signal, where Up is towards Brighton and Down towards the SECR and Hastings. Railway companies usually regarded destinations not on their network to be the Down direction. The signal is similarly vertically challenged to the box for canopy sighting reasons. The side-mounted ladder is a practical means of avoiding the lamp carrier going anywhere near the live rail. Note how the bullhead rail is used as a fender to stop a vehicle or platform trolley going on the tracks.

The building across the tracks is a sub-station for the 750 V DC supply and it appears to date from the line's electrification in 1935. The wooden ramps outside the building assist the change-out of heavy electrical equipment such as rectifiers and transformers. June 2008.

The reason for the lowness of box and signal is revealed in the attractive and expansive station canopies. Note the wide platforms to accommodate hundreds of swirling holidaymakers, expectantly milling about and looking for the exit. The footbridge looks like a later replacement. June 2008.

The exits from the platforms are also capable of handling the crowds up to the fine station building and the roadway. The trailing crossover in the distance is worked by a local ground frame. The distance that manually operated points can be from their lever has been reduced over the years from 450 yards (411 m), ¼ mile (440 yards or 402 m) to 250 yards (229 m) and less again if the points are facing. There is a further semaphore signal on the Up right-hand side beyond the crossover. June 2008.

Bexhill station building has charm and a certain self confidence as the survivor of the two stations in the town. June 2008.

Havensmouth (-)

Date Built	LBSCR Type or Builder	No. of Levers or Panel	Ways of Working	Current Status (2016)	Listed Y/N
1999	Railtrack Portakabin	IFS Panel	Gate	Removed	N

This box is at the seaside hamlet of Normans (sic) Bay; and the name is not related to the Conqueror, whose forces were said to have arrived at Pevensey down the coast.

Normans Bay station is 25 miles and 77 chains (41.78 km) from Brighton station.

Pevensey (CCV)

Date Built	LBSCR Type or Builder	No. of Levers or Panel	Ways of Working	Current Status (2016)	Listed Y/N
1876	Saxby & Farmer Type 5 (LBSCR)	14	AB	Closed 2015, due demolition	N

A Roman fort existed before William the Conqueror, the future ruler, used this building, which still survives as a ruin. It was immortalised by the renowned artist J. M. W. Turner.

Pevensey is also the site of a Martello Tower, constructed to rebuff Napoleon, and so has had more than its fair share of unwanted guests.

The signal box is located at Pevensey and Westham station, while the village also has Pevensey Bay station about ¾ of a mile (1.2 km) away.

Pevensey and Westham station is 23 miles and 7 chains (37.16 km) from Brighton station.

Havensmouth did not feature among the clamour raised on the south coast for getting signal boxes listed when folk realised their signal boxes were under threat. It was not present on Google Maps' satellite view dated 2016. The milepost informs us we are 26 miles from Brighton. June 2008.

Normans Bay station is in minimalist mode, looking towards Pevensey and Brighton. The grey box on the track beside Platform 2 is a train detector treadle that does not allow barriers to be raised until the whole of the train has passed over the crossing. June 2008.

Above: Although the box is early, it has been seriously messed about with and so would be an unlikely candidate for listing. The windows and loss of upper clerestory glazing, together with galvanised steps, would not assist any listing application. The name of the signal box is just Pevensey and the name board is a station platform nameboard type. June 2008.

Right: The semaphore signals nearest to the box seem to survive the longest and this starter for the Up line to Hampden Park and Eastbourne is right across the crossing from the signal box. The blue lens worked well here as the original oil lamps shone a yellow light: the blue plus yellow gave a green light to oncoming trains. June 2008.

The station signal box and signal make up this tableau from the footbridge. June 2008.

Pevensey and Westham station building looks the part for a seaside location and has managed to order the correct weather for such a location. Even the wooden shed on the platform has decorative touches to it. There is a bracket signal down by the high-visibility-jacketed track worker down the line. June 2008.

Pevensey station building. The canopy over the doorway is a thoughtful addition for travellers alighting from a horse-drawn cab or pony and trap at the time of the station's construction. June 2008.

Hampden Park (CDB)

Date Built	LBSCR Type or Builder	No. of Levers or Panel	Ways of Working	Current Status (2016)	Listed Y/N
1888 circa	LBSCR Type 2b	24	AB/TCB	Demolished February 2015	N

The station is on the outskirts of Eastbourne and was originally named, as was the box, Willingdon, which is the name of the double junction between Brighton and Bexhill.

Hampden Park station is 21 miles and 75 chains (37.16 km) from Brighton station.

The entrance way into the station building at Hampden Park seems understated but is possibly overshadowed by Eastbourne just down the line. June 2008.

51

As at Pevensey, the box had been heavily modified with an incongruous extension and so lost any chance of listing when the route was re-signalled from 2013 onwards. There were no semaphore signals either here or at Eastbourne at the survey date. Pedestrian access is denied in five languages. June 2008.

The wooden station building at Hampden Park is charming, and is complete with a LBSCR signature curved roof canopy. Colour light signals go as far as the eye can see. The view is towards Eastbourne. June 2008.

Eastbourne (EB)

Date Built	LBSCR Type or Builder	No. of Levers or Panel	Ways of Working	Current Status (2016)	Listed Y/N
1882	Saxby & Farmer Type 5 (LBSCR)	Nx Panel	TCB	Closed February 2015	Y

The large seaside resort of Eastbourne suffered somewhat from its image of having residents of an advanced age, but that has since brightened somewhat with a large student and commuter population giving a population with a more youthful average age. A non-local member of the aristocracy, the Duke of Devonshire, is credited with turning a collection of villages in to the town. Consequently, there are numerous references to the Cavendish family name in the town.

Eastbourne was different from many other seaside resorts in that it lost its semaphore signals relatively early; when this occurred, it was very often due to some incident that highlights a perceived signalling deficiency. The Eastbourne railway incident occurred on 25 August 1958 and was attributed to a driver missing a semaphore home signal at danger.

A sleeping car express from Glasgow was continuing to be steam hauled over the SR metals and had made up time on the approach to Eastbourne station. A twelve-car EMU set was ready to depart from Platform 4 and was 4 minutes late at that point. The driver of the steam locomotive, BR Standard Class 5 4-6-0 No. 73042, over ran a home signal at danger at a speed of 25 mph (40 km/hr) and went through points set against it into the already occupied Platform 4. The subsequent collision with the EMU claimed five lives and caused forty injuries. All the fatalities were in the EMU set; the sleeper train was no doubt saved from a similar loss by passengers being in their sleeping compartments. Part of the collision demolished a large semaphore signalling gantry, which mercifully fell away from the wreckage, but this event could only have speeded up the replacement of semaphore signalling from Willingdon Junction to Eastbourne. There had also been a buffer stop collision at Platform 3 in 1905.

Eastbourne signal box is 23 miles and 59 chains (38.2 km) from Brighton station.

This listed building is seen in fine fettle but with nothing to do, as the colour light signal from the Three Bridges ROC testifies. The stairway with landing and complicated woodwork is pure LBSCR, as is the walkway. Some attempt has been made to retain the round-topped window frames, at least in the front windows at operating floor level. The locking frame windows have survived despite Eastbourne being very heavily bombed in the Second World War; the platform canopies and engine shed were particularly badly hit. Copious use of strengthening bolts and discs is evident. The signal box had previously been equipped with a 108 manual lever frame, which was subsequently changed out for a Westinghouse A2 72 lever frame; this apparently remains in the box. July 2015.

A general view of Eastbourne station: the fine overall roof on the left continues in service despite having less to do now. The platforms are numbered 1, 2 and 3 from right to left and so, if the platform numbering has remained the same, the fateful Platform 4 described in the incident above is on the far left and is now disused. July 2015.

Pictured is an earlier view of the overall layout at Eastbourne when the box was still active. The signal box has the builders in and the crossovers in the foreground enable Down trains to access any platform or any platform to access the Up line. Down is towards the buffer stops.

The EMU servicing area is in the middle ground and there is a non-electrified engineer's siding at the far right, as well as others next to it and next to the running line. The view is from the Upper Avenue Road bridge. June 2008.

The overhang of the operating floor at the front continues round the back, while a fair bit of steelwork supports the lower brickwork. The roof overhang is very apparent in this view. June 2008.

Polgate Crossing (PG)

Date Built	LBSCR Type or Builder	No. of Levers or Panel	Ways of Working	Current Status (2016)	Listed Y/N
1883	Saxby & Farmer Type 5 (LBSCR)	20	AB	Closed 2015	N

Polegate progressed from a village to a town largely as a result of its status as a junction for the branch line to Tunbridge Wells. Houses were built by the railway for their employees; it was often one of the inducements needed to entice people to work in then-isolated locations.

The people of Polegate wished to retain and preserve the signal box after its closure in 2015, but a row developed when it was realised that, for safety reasons, the box would need to be moved from its current site.

Polegate has had three stations in all; the latest opened in 1986 and the branch line towards Tunbridge Wells (the Cuckoo Line) closed completely in 1968. There had also been a spur line to Pevensey. The second station survives as a restaurant.

The current station averages about 1 million passengers per year.

Polegate Crossing signal box is 19 miles and 34 chains (31.26 km) from Brighton station.

Polegate Crossing box has unusual locking frame windows, with an almost ecclesiastical form and the surrounds decorated with multi-coloured brickwork. June 2008.

Depicted is Polegate station with the Up starter signal a tubular post affair. However the signal retains the SR feature of the operating lever and counterbalance some way up the post. The original junction station for the line to Tunbridge Wells was about ¼ mile (0.4 km) back down the line towards Willingdon Junction. June 2008.

The view on the opposite side of the crossing on Polegate High Street, where vegetation breaks out. The trailing crossover in the foreground is not connected to the signal box in any way and there are no ground signals for a reversing move over it. Closer examination reveals that the crossover is out of use, and the straight moving rail or blade is held shut against its stock rail by a fishplate secured to the wooden sleeper by a chair bolt. The view is towards Brighton. June 2008.

Polegate signal box from the rear has a bricked-in portion on the left-hand side where perhaps a window was to be. There does not appear to have been a fireplace here, despite the box's early construction. June 2008.

Berwick (BK)

Date Built	LBSCR Type or Builder	No. of Levers or Panel	Ways of Working	Current Status (2016)	Listed Y/N
1879	Saxby & Farmer Type 5 (LBSCR)	17	AB	Closed 2015	Y

The village of Berwick rated a mention in the Domesday Book and has a Grade I listed church. However the village is about 2 miles (3.2 km) from the railway station, which should perhaps be called Berwick Road.

Berwick signal box is 15 miles and 55 chains (25.25 km) from Brighton station.

The journey now heads south at Southerham Junction, controlled by Lewes signal box, towards Newhaven and Seaford.

Berwick signal box basks in the early summer sun and displays bricked-up locking frame room windows that, as Berwick received attention from the Luftwaffe in the Second World War, are possibly a war-time modification. The extension to the operating room platform and steps for the toilet block on the right-hand side have been sympathetically done. The repetition of the name at the end is unusual and some areas of Network Rail only have the name board at the signal box ends. Note the oil-fired storm lantern hanging from the left-hand side. The brown growth on the left-hand side wall could be evidence of teapot emptying. June 2008.

Berwick station buildings are framed by the Down starter signal, complete with a tarnished mirror to assist the signaller to view traffic from behind the box. Crossing boxes sometimes have a special window built into the rear wall for such a purpose.

The waiting shelter scalloped barge boards are a typical Victorian piece of decoration for its own sake. The main station building on Platform 2 seems rather prosaic in comparison but has been modified more than the waiting shelter. June 2008.

The view towards Brighton along the platforms reveals the Up starter signal and a Down section signal. June 2008.

This view at Berwick is of the way to Polegate and Eastbourne, with the South Downs as a backdrop. Note the period galvanised dustbin on the operating room landing. The rail built posted home signal on the Up line completes the signalling scene at the station. June 2008.

The final view at Berwick is of the rail posted semaphore by the box. The Health and Safety ladders and hoops have not reached here yet. Observe how the signal arm is a steel pressing with a small angle on each long edge. June 2008.

Newhaven Town (CCO)

Date Built	LBSCR Type or Builder	No. of Levers or Panel	Ways of Working	Current Status (2016)	Listed Y/N
1879 circa	Saxby & Farmer Type 5 (LBSCR)	40	AB	Active	N

Newhaven's position at the mouth of yet another River Ouse did enable some port activity to take place. However, this was nothing compared to what happened after the arrival of the LBSCR.

Newhaven was the LBSCR's answer to the SECR's monopolistic control of cross-Channel ferry traffic at Dover, Ramsgate and Folkestone. The traffic to Dieppe continues now, with two sailings per day. The *Côte d'Albâtre* is the vessel DFDS Seaways now use and is featured, partially, in the section about the harbour.

In earlier years there had been a considerable amount of goods sidings and a steam locomotive depot; that required the signal box to be extended by about one quarter of its length, enabling the twenty-four levers to expand to forty-one. At the same time, the wooden signal box had a strengthening brick wall at the rear to support the Westinghouse A2 frame, which had come second hand from Three Bridges. There was also a gate wheel to operate the crossing gates.

The mileage changes here; Newhaven Town signal box is 56 miles and 20 chains (90.53 km) from London Bridge station via Redhill.

Above: This shot shows the box and its proximity to the road. It was this proximity that required the stairs and entrance way to be moved from the right to the left-hand end. Out of the forty levers in the box, only six are in operation and this is for signals only. The trailing crossover towards Harbour station was out of use at the survey date. The extension at the far end is evidenced by the locking frame windows being a pane short of a complete set at the far end. Astonishingly all the locking frame windows have survived this far, although the operating floor glazing appears to be a later replacement. June 2008.

Opposite above: Newhaven Town station looks to be a sleepy place, but still sees 320,000 passengers per year. The station building has an interesting mix of cast-iron columns supporting the canopy roof, which suggest an extension at some point. Note the bracket signal to control trains from Newhaven Harbour and the ship with its bow door open in the distance. June 2008.

Opposite below: This view of Newhaven Town signal box is included to highlight the brick-built rear wall put in to support the Westinghouse frame. In complete contrast to the wooden front and sides and worthy of note is the way the roof extends over the brick wall for a short way. At least the brick wall is strong enough to support the air conditioning units. The LBSCR pattern steps would seem capable of supporting the box if the wooden front were not able to. June 2008.

63

Newhaven Harbour (NH)

Date Built	LBSCR Type or Builder	No. of Levers or Panel	Ways of Working	Current Status (2016)	Listed Y/N
1886	Saxby & Farmer Type 5 (LBSCR)	42	AB, OTW	Active	N

Newhaven Harbour station was originally the destination for cross-Channel ferry boat trains until the later Marine station was opened. Newhaven Marine station has been closed for some years, apparently because the roof is unsafe. This means that passengers for the ferries are treated to a free bus ride from Newhaven Town station. The only train that visits Newhaven Marine now is the 8 p.m. Parliamentary train, which is obliged to operate without passengers to fulfil the operator's statutory parliamentary obligations.

The line curves around past Newhaven Harbour station to a single-track branch line to Seaford. The operation of the single-track branch line is described as 'one train working' without staff, or OTW. This system was originally invented for lightly used lines where, as its name suggests, only one train is allowed on to a single-line section. This was regulated

Newhaven Harbour signal box has no trains but there is a ship. There are rod-operated points and wire-worked signals here, as well as bullhead rail track outside the box. Newhaven Marine station is off to the left, as is the Seaford branch. June 2008.

in the past by the issue of a wooden staff to the train driver, which represented the driver's authority to proceed; clearly only one was ever issued at once. This way of working is now described as One Train Staff or OTS, and is still used in certain parts of the network.

The more modern version does away with the need for the physical piece of wood. It requires at least part of the single-track section to be track circuited. The section signal to enter the single line is the driver's authority to proceed, and this signal is locked against a further entry by the operation of a track section after the signal. When the branch line train has returned, it has to operate two track circuits at the branch, beginning sequentially, to unlock the section signal for further use. In the event of a track circuit failure, a complicated process has to be enacted by the use of a pilot, who travels with the train and acts as the physical token as in OTS working. PILOT in this case stands for **P**erson **I**n **L**ieu **O**f **T**oken.

Newhaven Harbour signal box is 56 miles and 58 chains (91.29 km) from London Bridge station via Redhill.

The next journey continues the LBSCR coast route towards Portsmouth.

The seemingly dangerous roof of Newhaven Marine station is the white-clad fascia structure in the middle ground, and the rail exit from the platform is protected by the rail posted semaphore signal. The platform is capable of handling a twelve-coach train; locomotive facilities are provided in the shape of a run-round loop. This piece of track is used to run round trains that have been diverted here as a consequence of a track problem in the Eastbourne area. The double slip in the foreground assists in the run-round process, while the four rods in the foreground would operate the slip with facing point locks. The point at the far end of the platform for the run-round loop is operated by the Wharf Road ground frame.

The SR kit-built concrete platelayer's hut seems disused. The Seaford branch heads off in the foreground to the left of the picture and is double track for only a short way. The branch is just over 2 miles (3.2 km) in length. June 2008.

65

Newhaven Harbour station sees only about 50,000 passengers a year and looks eerily quiet. The colour light signal 'feather' is for the Marine station and straight on towards Seaford. June 2008.

South Coast – Lewes to Havant

The journey starts at the county town of East Sussex, Lewes, continuing to the seaside behemoth of Brighton, and then to the county town of West Sussex at Chichester and finally to Havant.

Apart from at Bognor Regis, there is little mechanical signalling on this route. The figure below depicts a route that is set back from the south coast somewhat, and the sea is usually reached by a branch line south of the coastal route.

South Coast – Lewes to Havant

66

Lewes (LW)

Date Built	LBSCR Type or Builder	No. of Levers or Panel	Ways of Working	Current Status (2016)	Listed Y/N
1888	Saxby & Farmer Type 5 (LBSCR)	Nx Panel	AB, TCB	Active	N

Lewes is the county town of East Sussex and, before 1974, the whole county. It has ancient roots and is an administrative centre, as well as being firmly on the tourist map.

Lewes is the junction of four lines running into it:

1. A line to Brighton.
2. A line to Three Bridges to join up with the Brighton line on its way to Victoria station.
3. The line to Berwick and Eastbourne we have already travelled on.
4. The branch line to Newhaven we have just visited.

Lewes signal box looks substantially original, at least from the outside, with some hopper windows in place and curved tops to the main windows. The locking frame windows are bricked up, but we can get an idea of their brick framework arrangements by the near end door. The EMU in the background inhabits Platform 5, which is basically a loop on to the Brighton line, and the train is heading towards Brighton, away from the camera. The box unusually has a second NSE name board on the front window area for trains coming from the Plumpton direction. A sub-station exists behind the box. June 2008.

The general layout of Lewes station east end. The EMU and loop line to Brighton are followed, going right, by the double-track main line to Brighton. In the V of the platforms is the further double-tracked line to Plumpton, Keymer Junction and Victoria station. The line on the far right is for track maintenance vehicles. June 2008.

This is a look back towards the signal box and the lines to Berwick. The signal box has the prodigious LBSCR stair arrangement, modified for the outside privy or WC. The Down siding containing the track maintenance vehicle has its ground signal set against exit and the double railed trap point is similarly set. The South Downs provide an agreeable backdrop. June 2008.

There was a fifth line running north to Tunbridge Wells West, and this joined up with the line north from Polegate, as already described. A further branch from the fifth line ran through Sheffield Park and Horsted Keynes towards East Grinstead, and some of that line has survived as the Bluebell Railway.

The mileages are counted twice here; Lewes signal box is 50 miles and 3 chains (80.53 km) from London Bridge station via Redhill, and 8 miles and 3 chains (12.94 km) from Brighton station.

Plumpton (–)

Date Built	LBSCR Type or Builder	No. of Levers or Panel	Ways of Working	Current Status (2016)	Listed Y/N
1891	LBSCR Type 2b	21 IFS unpanelled	Gate	Active	Y

Plumpton is a thriving village but is probably best known for its racecourse. However, the railway installation still has a slightly more obscure but more enduring claim to fame – that of gate-wheel-operated crossing gates.

Plumpton signal box is 44 miles and 46 chains (71.64 km) from London Bridge station via Redhill.

Plumpton signal box is in fine fettle as a listed building; the rods coming out from the tunnel at the front of the box are for the crossing gate linkages and gate locks. Some gardening is going on here, with orange crocosmia in full bloom. June 2008.

69

The gate wheel has the signaller's duster hanging on it and some of the only three levers that are still operational are visible. The levers here now provide only a 'slot' or networked interlock for Up and Down signals and a gate lock lever. The IFS is for a trailing crossover and release. June 2008.

The box and gates have a customer in the shape of a Class 377 EMU, No. 377430, headed north from Platform 1. Just north of this location was the racecourse platform, on the same left-hand side as Platform 1, and the larger rusty footbridge after the regular one was the means of connecting trains from Platform 2 to the racecourse. We have seen the scalloped LBSCR waiting shelter fascia edging before at Berwick. Both main and subsidiary station buildings, plus footbridge are Grade II listed. June 2008.

The rear view of Plumpton signal box reveals a disturbance in the brick work pattern, which may indicate removal of a chimney stack before the listing. June 2008.

Lovers Walk Depot (--)

Date Built	LBSCR Type or Builder	No. of Levers or Panel	Ways of Working	Current Status (2016)	Listed Y/N
2005	Portakabin operated by Southern Railway TOC	IFS Panel	Shunt Panel	Active	N

Brighton achieved fame in the Regency period, with the future monarch popularising the town and leaving behind the legacy of the Royal Pavilion. Brighton was the inspiration for the *Brighton Belle,* a luxury Pullman electric train that ran from 1933 to 1972.

Brighton station is a Victorian temple to the railway age and one of the country's busiest, with about 17 million passengers a year.

Servicing modern rolling stock is the function of this location.

Lovers Walk depot signal box is 49 miles and 74 chains (80.35 km) from London Bridge station via Redhill.

The journey now resumes its westbound coastal trajectory where mileages are calculated from Brighton station.

71

Above: The Lovers Walk depot Portakabin and relay room, as seen from the Dyke Road Drive bridge. This small, hut-like structure is equipped with a vertical mosaic mimic panel that depicts the track layout within the depot. At a horizontal desk is the Individual Function Switch panel that operates points and signals. The depot entrance and exit signals are slotted or interlocked with the Three Bridges ROC. The panel supervisor controls the arrival and departure of trains and their movement within the different departments at the depot. To assist in the panel's operation is a radio, telephone and computer. October 2015.

Opposite above: Also from the Dyke Road Drive bridge, this time looking south, is this general view of the depot, with the double track running lines, one of which is occupied by Electrostar EMU Class 387 No. 387110. The washing plant is on the left, about halfway down the previously mentioned Electrostar train. The servicing sheds have the familiar yellow-and-black stripes on the doors. The branch off to Platforms 3, 4 and 5 of Lewes station is past the servicing sheds and takes off to the left, which is east. The depot Portakabin is down to the right and just out of shot. October 2015.

Opposite below: This view is a close up of the servicing sheds at Lovers Walk depot and the carriage washing line is on the left. The Class 09 shunter No. 09026, named *Cedric Warne*, is used to move trains around the depot, where the use of the third rail within servicing areas would be a health and safety issue. Note the ground signals present at each set of shed doors. October 2015.

73

Lancing (LG)

Date Built	LBSCR Type or Builder	No. of Levers or Panel	Ways of Working	Current Status (2016)	Listed Y/N
1963	British Railways Southern Region	Nx Panel	TCB	Closed On Sale	N

Lancing is notable for Lancing College, a famous public school, and the village was well known as a genteel seaside resort in the nineteenth century. Lancing was also known for the LBSCR's carriage works. Brighton had no more room for further development, as it already had the LBSCR's locomotive works, which continued building standard steam locomotives for BR until the 1950s. Lancing carriage works closed in 1965, but not before the workers from Brighton were transported to the works in the 'Lancing Belle', as their worker's train was ironically nicknamed.

Lancing signal box is 8 miles and 15 chains (13.18 km) from Brighton station.

Lancing signal box is pictured here with its crossing, and it is the latter feature that probably caused the box to survive among the many other closures and that destined it for greater things. The box controlled the line from Portslade station to Angmering, including Worthing, a distance of about 12½ miles (20.12 km) at the survey date. June 2008.

Barnham (BH)

Date Built	LBSCR Type or Builder	No. of Levers or Panel	Ways of Working	Current Status (2016)	Listed Y/N
1911	LBSCR Type 3b	75	TCB	Closed Moved	N

Barnham had a mention in the Domesday Book, and was a centre for market gardening and a cattle market in past days. Its main claim to fame now is the junction with the Coastway Line

Barnham signal box is here on its last legs operationally: one of the signals has already been removed and stacked behind the BH32 platform signal with its 'feather' for the Bognor Regis branch line. June 2008.

for Bognor Regis. The signal box was closed in 2009 and moved to the Bognor Regis Model Railway Club, where an arson attack severely put back volunteer efforts to restore the box.

Barnham was also involved in a bizarre accident in August 1962. There is a pair of facing points (Number 8) at the east end of the island platform; these give access to Platform 1, which is for Bognor Regis. They are electrically operated.

At the west end of Barnham station is a substation that is used to supply traction power. These substations are positioned about every 3½ miles (5.63 km) and it is not unknown for these stations to trip out under abnormal load conditions. This happened at Barnham and the result was to induce a stray voltage, which, with a chance electrical fault, caused the number 8 points to start to motor open when an EMU was travelling over them. As they are facing points, the EMU was derailed and badly damaged and, although there were injuries, there were no fatalities.

Barnham station is 22 miles and 29 chains (35.99 km) from Brighton station.

Bognor Regis (BR)

Date Built	LBSCR Type or Builder	No. of Levers or Panel	Ways of Working	Current Status (2016)	Listed Y/N
1938	Southern Railway Type 13	66	AB	Active	N

Bognor Regis, like Brighton, also benefitted from royal patronage. In the end, King George V was rather uncomplimentary about Bognor, but this did not prevent Billy Butlin from establishing one of his holiday camps at Bognor, and today Bognor is the headquarters of the Billy Butlin organisation.

Railway stations connected with seaside holiday resorts have tended to retain their semaphore signals longer than other places, and Bognor is no exception.

Bognor Regis station is 25 miles and 75 chains (41.74 km) from Brighton station and the signal box is 24 chains (482 m) nearer Brighton.

76

The view from the platforms at Bognor, looking towards Barnham and Platform 3, sees the departure of No. 313208 signalled. The platforms read, from left to right, 1, 2 and 3, with the shorter Platform 4 on the far right. The ground signal controls exit from the middle siding, which is now just a stock storage road. It did have a ground frame and crossover to release a locomotive from Platform 3 but has lost that between visits. Note that here, unlike the previous location of Littlehampton, there are no direct connections between the platforms and the carriage sidings, which are to the left of the platforms. July 2015.

Opposite above: Bognor Regis signal box is still in business here in 2015 but some of the stools for point rodding are unoccupied, implying that previously rod-worked points are now electrically operated. July 2015.

Opposite below: Bognor Regis signal box again, but some nine years earlier. The departure signal for the Up line to Barnham is on a massive bracket, and there are many more rod-worked points leaving the box. The extension office is not bricked up but is rather equipped with a blue door. The same ground signal with track circuited crossover and facing point lock is evident. The colour light signal would appear to be a repeater for the main semaphore arm and both signals were lever 13 in the frame. January 2006.

The Up departure semaphore is just visible from the signal post of the Platform 2 bracket signal. January 2006.

Further back, nearer train driver position, the semaphore is really difficult to make out and this issue probably hastened signal 13's removal. January 2006.

The station throat at Bognor in 2015. Many of the point rodding stools are unoccupied on the extreme right and grey point motors abound. Note that there is a ground disc signal for each road on the three carriage sidings on the right, while the carriage sidings exit is protected with a double-railed trap point. Any derailed stock would seem to threaten to take out the signal box. The solitary ground signal facing the camera is for a reversing move on the Up right-hand running line. July 2015.

Platforms 2 and 3 are occupied by service trains, while a third is in the carriage sidings. The release crossover and ground frame are still in position at this date. January 2006.

2015 sees no crossover at the end of the middle siding, but the plunger switch to release the crossover was still there at the visit date, mounted on a separate pillar. No. 313209 is at Platform 3 on the left, while No. 377436 is at Platform 2 on the right. July 2015.

As the railway to Bognor Regis had divided the town geographically, the LBSCR provided this footbridge to mitigate the inconvenience to pedestrians. One of the supporting pillars has this legend:

<center>H YOUNG & CO ENGINEERS PIMLICO LONDON</center>

The signal box is to the right and out of shot; this bridge provided the rostrum for some of the pictures. January 2006.

An earlier view of the ends of (from near to far) Platform 2, middle siding and Platform 3. The blue locking lever of the ground frame can just be seen as well as a telephone box. The release plunger is on the end of the handrail assembly but is obscured by the stop lamps. January 2006.

Chichester (CC)

Date Built	LBSCR Type or Builder	No. of Levers or Panel	Ways of Working	Current Status (2016)	Listed Y/N
1882	Saxby & Farmer Type 5 (LBSCR)	Nx Panel	TCB	Active	Y

Chichester's origins date back to at least Roman times, and the ancient walled city is an internationally renowned arts centre with the Chichester Festival.

There is a set of sidings for Dudman Aggregates, and a facing crossover was used to access the sidings from the down line towards Portsmouth.

Chichester signal box is 28 miles and 60 chains (46.27 km) from Brighton station.

Chichester signal box exterior is extolled by Historic England; they seemed to like the decorative brickwork around the locking frame window apertures and ground floor door. They were less complimentary about the interior. The listing of the signal box was accompanied by the rather ornate sewer pipe at the far right-hand end, which is also listed. The Nx Panel was installed in 1991 and was second hand from Three Bridges then. The casement windows at the front look original but, at the near side, they have been heavily modified.

The facing crossover for the Dudman Aggregates sidings is in the foreground and part of Shunting Neck No. 1 (of two) is in the foreground. Note the 28¾ mile post outside the box. The buddleia in bloom at the far end is one of those often planted by the early railway companies and has survived without any listing. July 2015.

Havant (HT)

Date Built	LBSCR Type or Builder	No. of Levers or Panel	Ways of Working	Current Status (2016)	Listed Y/N
1876 circa	Saxby & Farmer Type 5 (LBSCR)	64		Closed	Y

Havant has been the junction with the LSWR 'Portsmouth Direct' line for many years and remains so today. Havant was also the junction for the Hayling Island branch line.

Havant signal box is 37 miles and 28 chains (60.11 km) from Brighton station and 66 miles and 20 chains (106.62 km) from Waterloo station.

Historic England had no such listing truck with Chichester station and even the footbridge has escaped their attentions. It appears to be similar to the H YOUNG & CO one at Bognor Regis but is cranked to save space at the location. The EMU is headed for Brighton and the signal box is at the opposite end of the station. This view is at the Stockbridge Road/Southgate road crossing. July 2015.

The Havant signal box, now retired, still looks as though it could signal trains with some judicious pruning. The windows have been criticised for not being in keeping with the original LBSCR design, but look reasonably authentic from a distance. The Southern practice of retaining the name board after the box has shut has been repeated here. July 2015.

83

No. 313011 is arriving from the east, Brighton to be precise, and is coasting under the footbridge and past the box to Havant station. The LSWR London–Portsmouth 'Direct Line' is to the left. Note how there is a separate power actuator output for the facing point lock on the grey point motors. July 2015.

The opposite view from the footbridge shows that the Class 313 has just departed from the platform on the left for the Portsmouth direction. Meanwhile No. 444011 is departing with a train for Waterloo station. Havant station used to have central avoiding lines that could be used by freight or through traffic, but these have been removed. July 2015.

Isle of Wight Railway

The Isle of Wight Railway owned 14 miles (22.5 km) of route miles of railway lines between Ryde and Ventnor. It remained independent until Grouping in 1923.

The railway operated the lucrative holiday trade route from the ferry terminal at Ryde to the very south of the island at Ventnor, through the popular resorts of Shanklin and Sandown. The island's railway closed as steam in 1966. The line was electrified with the third rail system in 1967 and still uses ex-London Transport 1938 tube stock. The system runs under the aegis of Island Line Trains and, in 1991, a platform junction was put in at Smallbrook to connect with the Isle of Wight Steam Railway heritage line, although there is no physical track join up.

The figure above is a diagrammatic and not-to-scale diagram of the whole of the Isle of Wight line and its stations, together with the unconnected Isle of Wight Steam Railway heritage line.

Isle of Wight Railway

Ryde St John's Road (WFP)

Date Built	LSWR Type or Builder	No. of Levers or Panel	Ways of Working	Current Status (2016)	Listed Y/N
1928	Evans O'Donnell (ex-SER)	30 Panel	AB/TB/OTW	Active	N

As with much of the island's railway equipment, the signal box is second hand, coming from Waterloo station. Evans O'Donnell was one of the later signalling contractors who did work for the SER, Barry Railway and Great Eastern Railways.

The box retains some semaphore signalling around Ryde St John's station and works. The box also works Tokenless Block between Smallbrook Junction and Sandown, and OTW between Sandown and Shanklin. It is all controlled from this box.

This signal box has been thoroughly modernised but still retains some character touches, including the gardening. April 2016.

Tokenless Block Operation

Let us suppose that a passenger train from Smallbrook Junction (SJ) is to be passed to Sandown (SN).

The Tokenless Block instrument has three possible indications, of which only one is ever displayed at once; all equipment is in Ryde signal box:

1. Normal (line blocked or no permissions granted)
2. Train in Section.
3. Train Accepted.

There are also an Offer button, Accept button and Train Arrived button at both signal box instruments.

To pass the train from SJ to SN, the signaller at SJ presses the Offer button and, if SN selects Accept, this is reflected as **Train Accepted**.

This then locks all the signals on the single line from SJ to SN at danger.

When the train has arrived in the section at SJ, the track circuits sense this and turn both tokenless block instruments to Train in Section.

When the train has arrived at SN, the signaller selects Train Arrived and the instrument indications at both places revert to Normal. This operation is interlocked with any points on the route, and the system is then ready to dispatch another train in either direction.

This figure gives an overview of Ryde St John's station platforms and a glimpse of the works, where the Class 483 ex-Tube stock is maintained. The Class 483 on view is in ex-London Transport livery, as seen in the 1960s. The road between the platform and the works is known as the platform siding, and it does not have signalling compatible with passenger trains departing from it; consequently it looks like a stock storage road for sets going into or coming out of the works, or stabling for stock at night. April 2016.

The format now is to follow a journey in both Up and Down directions, mapping the signals en route. The Island Line runs north to south and, sensibly, up is towards Ryde Pier Head and down is towards Shanklin.

Ryde St John's Road signal box is 1 mile 22 chains (2.05 km) from Ryde Pier Head station buffer stops.

Above: The sub-journey begins in the Down direction towards Shanklin with this rail built posted Southern Railway home signal. The tube stock has a maximum speed of 35 mph (56.33 km/hr) and so movable distant signals would not be required at maximum speeds of less than 40 mph (64.37 km/hr). This location is north of Ryde St John's station and is near the 391 yard (357m) Ryde Tunnel. Note the three yellow flange greasers. April 2016.

Opposite above: This Down platform starter signal has become a bracket signal as well in that it accommodates two ground or shunting signals. The left hand is for a departure from the trap pointed platform siding, while the right is for a reversing move over the trailing crossover. There are only ever two destinations for the Class 483 and the return to Pier Head is already set once the train has reached Shanklin. Note the ground signal in the distance and the single-railed trap point on the left-hand platform road. April 2016.

Opposite below: This is the ground signal in the previous figure; it appears to give access to the facing crossover for the works and EMU servicing area. The tracks read, from left to right:

1. EMU servicing
2. Down Main Line
3. Up Main Line.

April 2016.

89

This is the first signal on the return Up journey towards Ryde Pier Head. The double track to Smallbrook Junction in the Down direction continues for less than 1 mile (1.6 km). Note the track maintenance vehicles in the EMU servicing siding head shunt or shunting neck. The yellow warning panel is an obligatory addition to the London Transport livery on the Class 483. April 2016.

With the Ryde St John's station platforms in the distance, this pair of ground signals control crossover movements. The white faced signal is the twin for reversing over the trailing crossover that we saw on the right of the signal post in the image above.

The black-faced and yellow-striped signal permits shunting on the neck backwards and forwards, but any exit from the crossover and the signal must be off. April 2016.

At Ryde St John's Road station on the Up platform is this colour light signal. This modern item may have been the result of a driver's complaint or some incident. Note how low the platforms are, and also the Isle of Wight Railway cast-iron spandrels picked out in white. April 2016.

Passengers entrain at Ryde St John's for points south. April 2016.

Finally at Ryde St John's Road is the traction maintenance depot or former works with some of the original 1864 building still in use as Track 3 and the wash line on Track 4 on the far right. April 2016.

Brading (–)

Date Built	LSWR Type or Builder	No. of Levers or Panel	Ways of Working	Current Status (2016)	Listed Y/N
1882	Isle of Wight Railway	30	Museum	Closed to traffic	Y

Brading was a Roman sea port and the station was the junction for the line to Bembridge; relics of that era, whose line closed to passengers in 1953, are still evident.

The Southern Railway made the section from Brading to Sandown double track in 1927 as a measure of the popularity of the Isle of Wight seaside resorts. Brading was one of the last stations in Britain to retain gas lighting until the 1980s. It keeps that bygone era feel.

Brading station is 4 miles 55 chains (7.54 km) from Ryde Pier Head station buffer stops.

Brading signal box is in fine fettle, even though it has not controlled a train since 1988, when all the Island Line's signalling was concentrated at Ryde St John's. The signal box retains a high level of equipment and is open as a demonstrable museum on occasions. April 2016.

As well as the signal box listing, all the station buildings and footbridge are listed at Brading. The Class 483 waits to head off to Sandown and Shanklin. The footbridge is now judged to be unsafe and access is barred for casual users. The line from Bembridge ran in on the other side of the island platform, to the extreme left. April 2016.

This is the view towards Ryde: here the platform appears to be left as it is, with the rail level built up to accommodate the lower height of the Tube stock doors. The curiously abrupt end to the platform canopy on the left is not original and, when built, the canopy was faired in with the roof up to the base of the chimney stacks. The island platform has taken on a somewhat agricultural appearance, but is kept well mown. The signal box lurks behind the island platform. April 2016.

The faux gas lamps on the platform have the see-saw arm with chains and loops, where the gas was turned on and off by using a pole with hook on the end. April 2016.

The main station building at Brading has a blue plaque that informs us that the station was opened in 1864. The station sees about 50,000 passengers per year but is bucking the mainland trend by experiencing a significant decline. April 2016.

References & Acknowledgements

Acknowledgements

The kindness and interest shown by railway staff.

References

Books and printed works

Signalling Atlas and Signal Box Directory – Signalling Record Society

Quail Track Diagrams Parts 3 and 5 – TrackMaps

British Railways Pre-Grouping Atlas and Gazetteer – Ian Allan

Internet Websites

John Tilly's collection of signal box information on the web site:
www.tillyweb.biz/gallery/odyframe.htm

Adrian the Rock's signalling pages:
www.roscalen.com/signals

The Signalbox – John Hinson:
www.signalbox.org

Wikipedia
www.wikipedia.org

Southern E-Group:
www.semgonline.com/location/signalboxes/sbpolegate.html

Goods & Not So Goods:
myweb.tiscali.co.uk/gansg/3-sigs/gndsigs.htm

Southern Electric Group:
www.southernelectric.org.uk/features/infrastructure/east-kent-resignalling/eksig03.html

Historic England:
historicengland.org.uk/listing/the-list/

The Bluebell Railway:
http://www.bluebell-railway.co.uk/bluebell/tokens.html